A Happy Book of
LITTLE GIFTS
TO MAKE

SARAH HAND

Inspiring | Educating | Creating | Entertaining

Brimming with creative inspiration, how-to projects, and useful information to enrich your everyday life, quarto.com is a favorite destination for those pursuing their interests and passions.

© 2022 Quarto Publishing Group USA Inc.
Text and artwork © 2022 Sarah Hand

First published in 2022 by Walter Foster Publishing, an imprint of The Quarto Group. 100 Cummings Center, Suite 265D, Beverly, MA 01915, USA.
T (978) 282-9590 **F** (978) 283-2742 **www.quarto.com** • **www.walterfoster.com**

Walter Foster Publishing titles are also available at discount for retail, wholesale, promotional, and bulk purchase. For details, contact the Special Sales Manager by email at specialsales@quarto.com or by mail at The Quarto Group, Attn: Special Sales Manager, 100 Cummings Center, Suite 265D, Beverly, MA 01915, USA.

ISBN: 978-0-7603-7462-7

Digital edition published in 2022
eISBN: 978-0-7603-7463-4

Printed in China
10 9 8 7 6 5 4 3 2 1

TABLE OF CONTENTS

INTRODUCTION

I've always loved to make things, for as long as I can remember. When I was 5, I used to check out a book from the library over and over again about making dollhouse furniture from things around the house. I was particularly entranced by instructions on how to make a lamp using a golf tee as the base, putting a piece of clay inside a toothpaste cap (the lampshade), and sticking the spike of the tee into the clay. It made the cutest mid-century looking lamp! Ever since then, I've been fascinated with making delightful things out of easy-to-find materials.

Making things is part of being human—it nourishes us, invites play into our busy lives, and adds to our sense of well-being. As we get older, life becomes more complex, and finding the time and space to make things becomes more of a challenge. It isn't impossible, though. By scaling projects down to a manageable—or even small—size and using common materials, we can remove the barriers to creating.

That's what you'll find in this book: mostly smaller, stepped-out projects that are meant to inspire delight and smiles. From antique-inspired spun cotton figures and a buoyant murmuration sculpture to high-five pop-ups, you will discover new things to make and give to friends and family who appreciate funny and sweet handmade gifts. The projects are jump starts for your imagination. Have fun and see where your inspiration takes you!

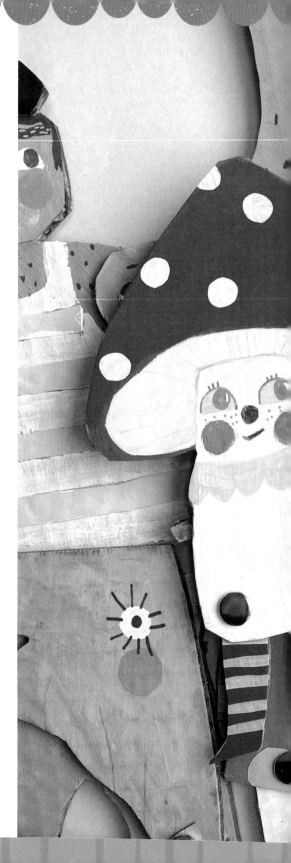

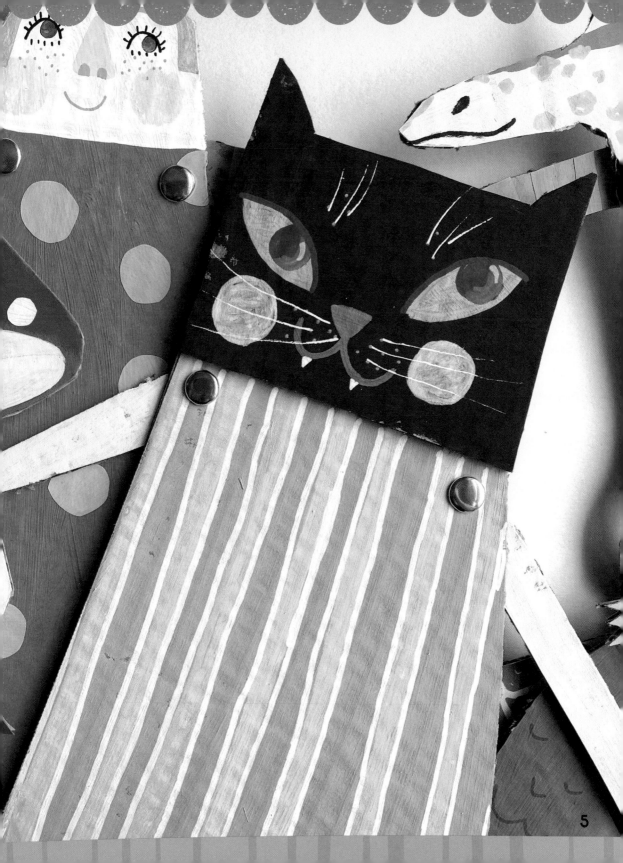

TOOLS & MATERIALS

I love easily found and inexpensive supplies. Having an abundance of stuff to play with is inspiring and gives you lots of options for your projects! This book uses many common supplies that you'll probably find knocking around your house, so take a look before you go shopping. Some of it is already in your recycling bin! The rest of the materials are easy to get, either at your local craft store or online.

The Basics

- Glue stick (I love UHU® brand)
- Ruler
- Scissors (nice to have a larger pair, as well as a smaller detail pair)
- Craft knife or box cutter with a fresh new blade
- White glue (Elmer's®, Mod Podge®, and so on)
- Hot glue gun
- Masking tape

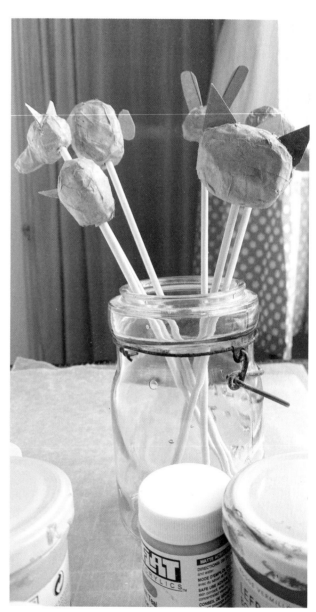

Paper & Cardboard

- **Card stock:** I use card stock in a lot of the projects in this book. It is just so handy to have a stack of it around for cards, books, boxes, tags, and much more. It comes in many colors, and you can find it at craft stores, office stores, and online. Sometimes you'll find packs of mixed colors, which are nice to have. I am a huge fan of the colors and textures from French Paper Company®.

- **Printer paper:** Regular old printer paper is cheap and bountiful. If stark white isn't your thing, you can get it in soft ivory, gray, or any color you like. I recommend having a ream of it around—you'll always find a use for it!

- **Brown-paper grocery bags** make a great sturdy paper for books, cards, and especially wrapping paper. Just save them after a trip to the store!

- **Newsprint/packing paper:** You can buy this in big packs at the hardware store (in the moving box section), or you can save the packing paper that comes in packages you might get in the mail. It's a soft, pulpy paper that is great for covering your work surfaces, printing wrapping paper, and crumpling for armatures (finger puppets and spun cotton).
- **Butcher paper:** You can find this all-purpose paper in rolls in brown or white. It is crisp and thin, and having a roll on hand is a great idea. I use it for painted paper, crayon rubbings, wrapping paper, table coverings, and more.
- **Corrugated cardboard boxes:** If you order things online, you're way too familiar with cardboard boxes. While I don't recommend hoarding all the boxes that come into your house, I do think hanging on to a few for crafts is a good idea. (See page 10 to learn how to prepare your cardboard.)
- **Premade postcards:** These are optional, as card stock will work as well. But if you like a preprinted stamp/address area, these are fun to use for the two-color foam-printing postcards (pages 124–133). You can find these online.
- **Thin cardboard** from cereal, seltzer, or other clean food packaging. Keep a couple on hand for projects like finger puppets, pipe cleaner heads, and so on.

Adding Color!

- **Acrylic paint** is my preferred paint, as it is permanent and can be layered without reactivating the other layers. Any kind of acrylic works for these projects: craft acrylic, fine-art acrylic, or acrylic gouache. I use them all! Experiment with different paints to see what you like.

- **Acrylic paint markers:** These are so fun to use for adding details, as well as drawing on top of acrylic paint. I highly recommend getting a handful of these marvelous pens. They come in oodles of colors, nib widths, and brands. You can buy sets or get them individually. Be careful—they are hard to resist!

- **Colored pencils:** When I don't want to get into my paints, I turn to colored pencils. They're fun to color, write, and draw with. It's worth it to get a good-quality brand. I recommend Prismacolor®; they're affordable, wonderfully pigmented, and buttery.

- **Crayons:** We only use them in one project, but crayons always come in handy. I recommend Crayola® or another decent brand. Stay away from toddler-friendly, super-soft, soy-wax crayons and blocks, as they simply squish too much to make a crisp rubbing.

Painting Tools

- Water jar
- Paintbrushes in a range of sizes
- Brayer: optional, for applying paint to foam stamps
- Paper towels: helpful for blotting your paintbrush!

Other Tools & Materials

- **Electric drill and bits** (see page 10 for helpful information)

- **Wood slices, blocks, chunks, chair legs:** These are available at craft stores and hardware stores, or you can cut your own if you have a saw. I also recommend checking out thrift stores for wooden blocks.

- **Craft foam:** The 6mm thickness is ideal for foam printing, but if you can only find thinner ones, that's OK too. See the instructions in "Two-Color Foam-Printed Postcards" on pages 124-133 for how to deal with thinner foam.

- **Rubber stamps:** A set of alphabet rubber stamps is helpful if you don't like your handwriting or just want a different look. Stamps with images are handy for paper-tape stickers, wrapping paper, and other projects in the book.

- **Cotton balls:** A regular old bag of cotton balls from the drugstore is perfect. You'll need these for "Spun Cotton Ornaments" on pages 16-23. If there's a choice of jumbo cotton balls, get them!

- **Small dowels or thick skewers** for "Finger Puppets with Stands" (pages 58-65)

- **An awl or thick needle** for poking holes

- **A bone folder** with a point or a dull butter knife for scoring (page 10)

- **Fabric scraps:** small bits for finger puppets

- **Brads/paper fasteners:** You'll need little ones and the larger brass ones.

- **Chenille stems:** Make sure you get a nice selection of colors you love. Making pipe-cleaner people is so easy and fun, you might want to make a whole pile of them!

- **Floral wire:** 26-gauge for "Murmuration" (pages 24-31) and something a little thicker—18-gauge, for example—for "Spun Cotton Ornaments" (pages 16-23).

- **Aluminum foil**

- **Water-activated paper tape:** This comes in two types—plain or reinforced. Reinforced has strings running through it to make it super strong. You can use either one, but know that if you use the string version, you'll retain that texture. See page 10 for my ode to paper tape!

TECHNIQUES

Each project has clear explanations of the techniques you will use; however, there are just a few things I'd like to explain more thoroughly before you begin!

Scoring

This is an extremely helpful technique to have in your repertoire when you're working with paper. Scoring is simply making an indentation along the line of a fold. It makes your fold clean and crisp. You will need a ruler and a bone folder with a pointy end or, just as good, use a dull (non-serrated) butter knife. You line your ruler up on the place you want to make the fold and run the knife or pointy end of the folder firmly along the edge. Now when you fold your paper, it'll be so tidy and satisfying! Once you try it out, you'll love it.

Using a Drill

You will need a drill for a few of the projects in the book. Drilling is easy, but it's a great idea to test out the size of your chosen drill bit before using it on the wood for your project.

Hold the block firmly, and then drill straight down into the block. Test your dowel or wire for fit. When I'm making a hole for a dowel or piece of wire, I want to get a snug fit, so it's worth drilling some test holes in a piece of waste wood. I keep a block of wood on hand just for this purpose.

Preparing Cardboard

If you're using cardboard for this or that, it pays to have it prepped beforehand. If you have kept a few boxes for cardboard fodder, do the following for ease of storage and use:

- Break the box down like you would if you were recycling.
- Grab a box cutter or craft knife and cut the flaps and sides of the box into their segments so you have uncreased sections to use.

I know this is simple, but I find it really cuts down on clutter and time to have a small stack on hand!

Ode to Paper Tape

You don't see water-activated paper tape around as much as you used to. It's definitely still used on shipping boxes, though, and can be found if you look for it. It's exactly what it sounds like: tape, made of brown paper, with a water-activated gum on the back (like an envelope). I've recently become enamored of it!

It's completely biodegradable, it has many uses, it comes in several widths (I like using the 2¾-inch width), and one roll will last you through hundreds of projects! You can paint it, print on it, draw on it, use it for collage, and reinforce handmade boxes for gifts you give. And you will still have enough left over to use as actual packing tape!

I prefer the plain brown tape that doesn't have the reinforcement strings running through it, but both kinds work great. Use a paintbrush and water or a damp sponge to activate the sticky back—don't lick it, OK? I hope you enjoy it as much as I do!

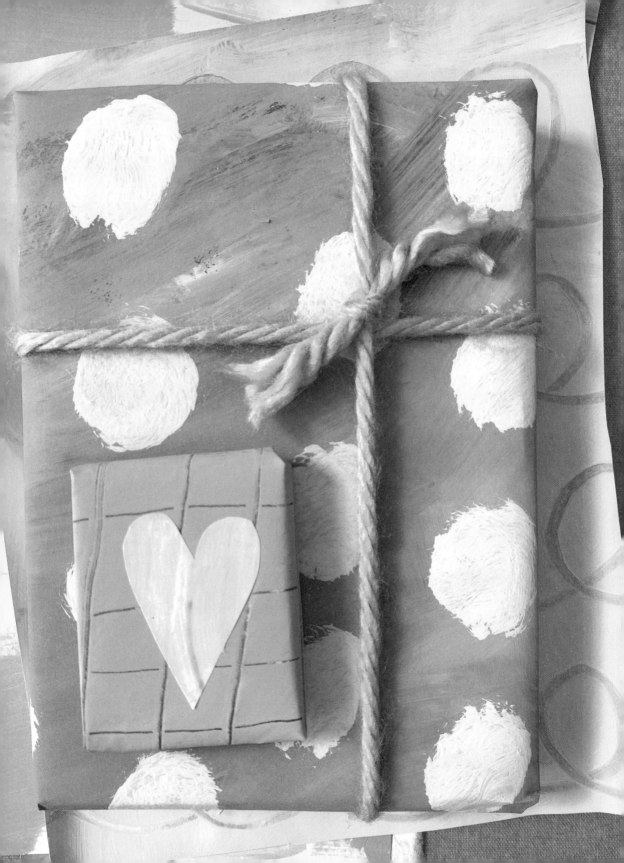

FINDING FACES

This book has lots of projects that require faces: animals, made-up creatures, people—you name it! To help inspire you to find new ways of making faces, I'm sharing a few hints and tips that help me. Have a go and see what you find!

 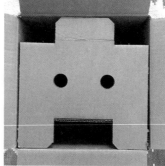

Look at the world around you. I see faces everywhere—cracks in the sidewalk, the clouds, a pile of paper scraps, and all around my house. If you see faces too, the best thing you can do is take photos of them. You can record faces as they appear, and later you will have a whole menu of them to choose from when you need a bit of inspiration. I like to use a little sketchbook to interpret my photos too.

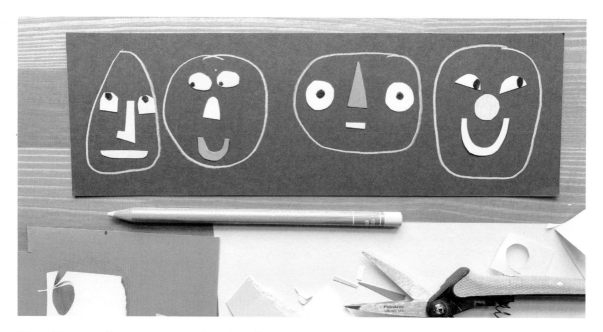

Play with paper: Use some scraps of card stock to make eyes, noses, mouths—even ears! Don't get too complicated. Mix and match them, and play around with their configuration until you find some faces and expressions that delight you!

MAKING HATS

Hats make everything better...right? I love to add hats to the characters in my drawings, paintings, and sculptures for just a tiny bit of whimsy. Here are a few ways to add hats to some of the projects in this book.

Cone Hat Tutorial

 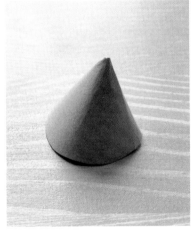 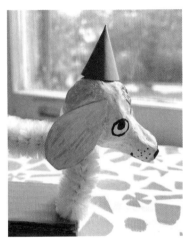

Step 1

Use a compass to make a circle. Cut the circle into wedges. A bigger wedge makes a wider hat, and a smaller wedge makes a narrower hat.

Step 2

Overlap the cut edges until the hat looks the way you like it. Use a glue stick to secure the overlap and hold until it's dry.

Step 3

Try it on for size! This dog looks much more festive now!

Hot glue a pom-pom to a hat for extra flair!

Use paper and a glue stick or painted paper tape to make party hats!

PRESENTATION

Once you've made a whole lot of kooky, fun projects, what do you think about giving some of them as gifts? Of course, you can keep as many as you want for yourself. But if you've made something for someone special, you'll want to present it to them in a fun way!

Here's a step-by-step folded envelope and handprinted wrapping paper tutorial. These are great when you've run out of envelopes and wrapping paper, or if you don't feel like buying any. And it's fantastic if you're dedicated to recycling and using what you have. Enjoy!

Folded Envelope

You can use any size paper to make envelopes. Here, I'm demonstrating using a piece of painted printer paper.

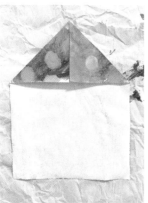

Step 1

Fold the top two corners.

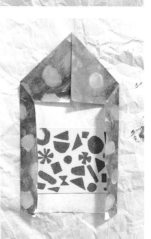

Step 2

Fold in the side edges to fit the card you're planning to put into the envelope.

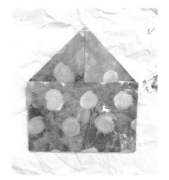

Step 3

Remove the card, fold the bottom up as indicated, and crease.

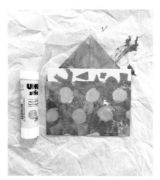
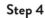

Step 4

Glue the folded side edges and fold back up. Press to adhere. Fold the flap down.

Step 5

Once the glue is dry, you can pop the card in. Glue (or tape) the flap closed. How easy is that?!

Wrapping Paper

There are many ways to gussy up some paper. Use whatever paper you've got on hand: brown paper bags, packing paper, butcher paper, printer paper, and so on. Anything goes!

- Make a foam stamp. I mounted mine on a wood block for easy printing. You could mount it on thick cardboard too. I love polka dots for wrapping paper. They can be used for any festive occasion just by switching up the colors.

- Use leftover paint on your palette from other projects by scrubbing it onto some paper for a textured wrap. Bring in a paintbrush to make squiggles or dots!

- If you have some rubber stamps, you can print them over painted paper for a whimsical custom wrapping paper.

- And if you don't have time for printing, grab some dot stickers (they come in a bunch of colors), wrap up a gift with some plain paper, and then stick dot stickers all over it!

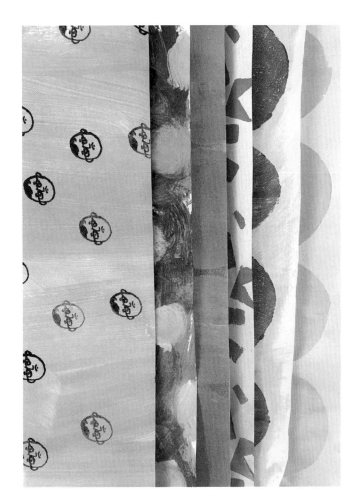

Gift Tags

Use scraps of card stock or wrapping paper to make tags for your gifts! Poke a hole through the tag and use string to attach it to a present. Nothing could be simpler.

Have fun with this. Your gifts will stand out!

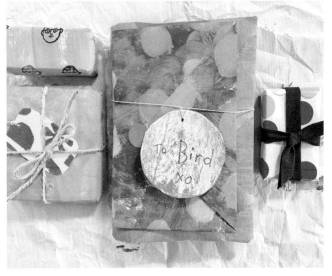

SPUN COTTON ORNAMENTS

Spun cotton ornaments are an art form from the 19th century. If you search online, you'll find many intriguing images of old, odd little figures. You will also find many contemporary examples that are just as charming. There is no one right way to make spun cotton ornaments. Every artist adds their own twist. No matter the technique, however, spun cotton creations are whimsical and cozy...and just a little bit different!

TOOLS & MATERIALS

- Aluminum foil
- Hot glue gun
- Masking tape
- Wrapped floral wire or plastic-coated wire (or you can wrap your own plain wire with masking tape to prevent rust)
- Cotton balls

- White glue
- A small dish
- Water
- A flat paintbrush (½ inch or so)
- Acrylic paints
- Optional: pom-poms and glitter
- Scissors

These are so fun and sweet to make. However, they do require a bit of a learning curve. If you find yourself frustrated and not liking the first one you make, that is normal. My first one was so bad! But as your fingers get used to working with the materials, you'll find your groove. Don't give up after one, OK?

Trust me!

The basics of spun cotton: Make a small armature, cover it with cotton, and paint it! It's a process, but you can take it in stages and have great results.

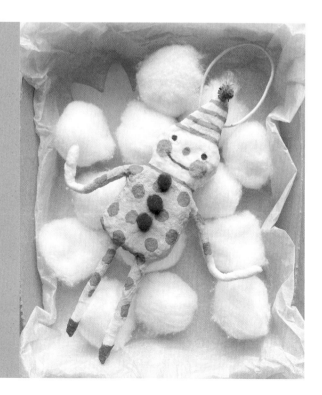

Make the Armature

Step 1

Make a little body and head out of aluminum foil.

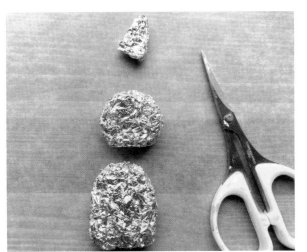

Step 2

Hot glue them together. I've decided to make a little hat for my figure, so I crumple another little bit of foil for that too and glue it on. You can add all sorts of foil details: ears, snouts, hats, and so on.

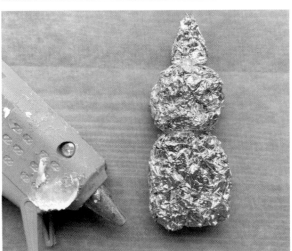

Step 3

Cover the whole thing with masking tape as shown.

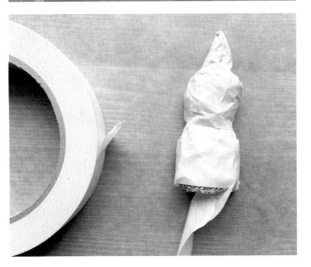

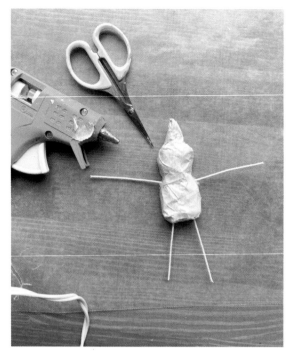

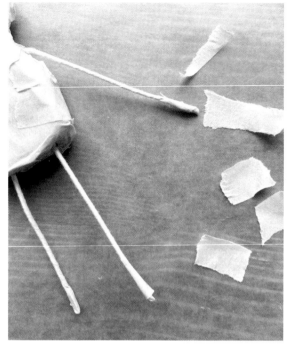

Step 4

For the arms and legs, cut pieces of wire. Use an awl or super sharp scissors to poke holes where the arms and legs go. Blob a bit of hot glue in the holes and insert the wires for the arms and legs.

Step 5

Even when using coated wire, wrap the exposed cut ends of the wire with small bits of masking tape to prevent rust.

Step 6

Make a hole in the top or back of the head (wherever it makes sense for you to add a loop for hanging). Add a blob of hot glue and insert the loop of wire into the hole.

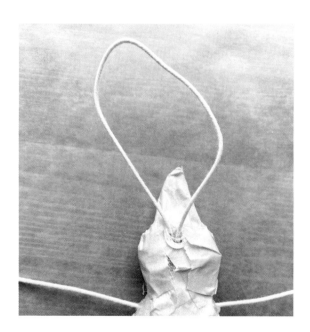

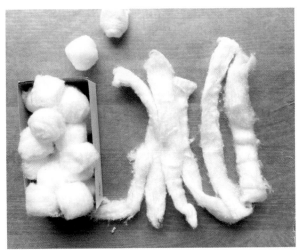

Now for the Cotton

Step 1

Grab five or six cotton balls and unroll them. Do this before you begin working with the glue.

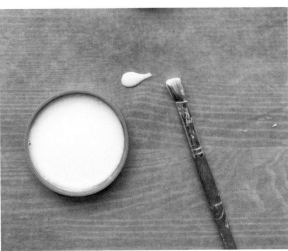

Step 2

Make a mixture of glue and water (half glue and half water), and mix it well.

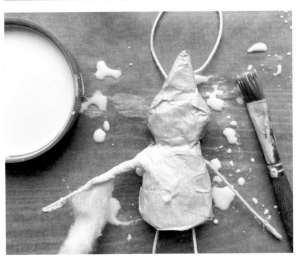

Step 3

Let's start with the arms and legs. Brush the glue mixture on a limb and using a long strand of cotton, start from the spot where the limb and the body meet, and wrap the cotton around the wire, using your fingers to make sure it's closely adhered. Keep brushing glue on as you go. You want the cotton to be fairly saturated with glue.

Step 4

Once you get to the end of the limb, wrap and glue the cotton back to where you started, creating a double layer.

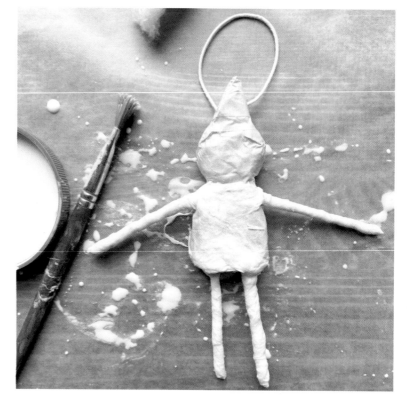

Step 5

Cover the body with cotton too. Brush glue on the armature, place chunks of cotton down, and then brush more glue on top of the cotton, smoothing as you go. Keep going with this until you've completely covered the armature. If the cotton layer seems too skimpy, keep adding layers of cotton until it looks fluffier.

Then let your ornament dry! It takes a little while. Make sure it can get some air circulation and/ or direct sunlight. Turn over if necessary to make sure each and every bit is dry.

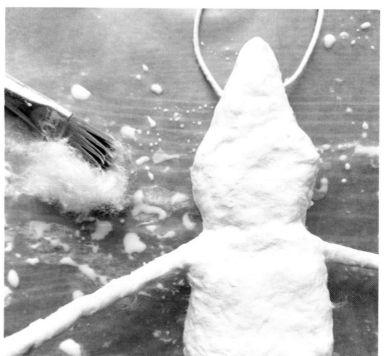

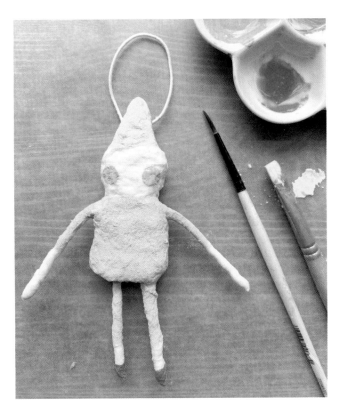

Paint!

Step 1

I like to use acrylic paint—any kind will work great. The cotton takes paint very well; it just kind of soaks in. I find that thinning the paint with a little bit of water from your paintbrush makes it soak in better.

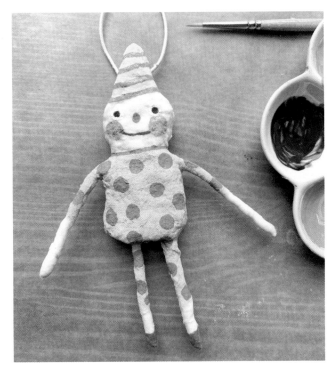

Step 2

I love to paint my spun cotton friends very simply with bright colors. I mean, look at this fellow!

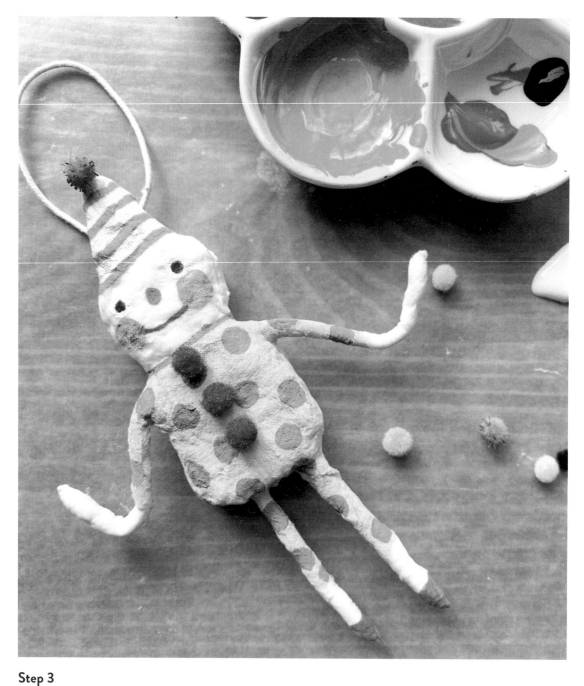

Step 3

Add pom-poms if you like. You can add all sorts of decorations! Glitter would be delightful too.

Because you've used wire for the arms and legs and the cotton is soft but adhered, you can gently position the arms and legs.

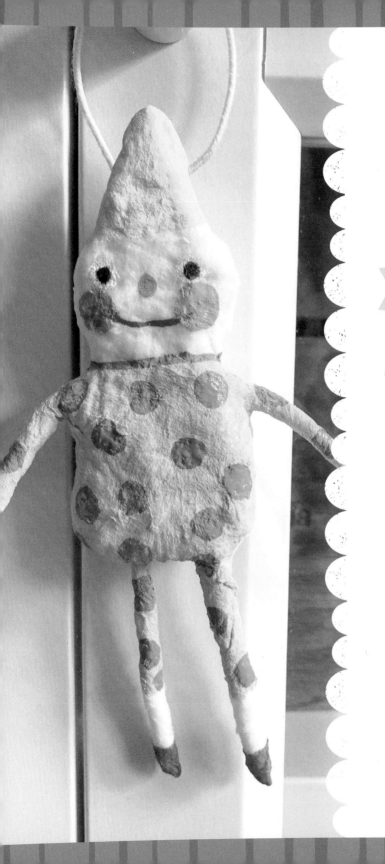

TRY THIS TOO!

Traditionally, spun cotton ornaments are for holiday decorating. But how fun would it be to leave off the hanging loop and make a little set of these for a dollhouse?

MURMURATION

Have you ever been lucky enough to see a murmuration? It's a huge flock of starlings flying in a formation, twisting, turning, and spiraling together. It's truly magical.

A murmuration inspired this project. It's a kinetic sculpture that looks lovely, is so easy to make, and can easily be customized. Wired paper birds move buoyantly when touched or when they catch a breeze.

TOOLS & MATERIALS

- Block of wood, any shape. I'm using a repurposed chair foot I found at a thrift shop.
- Drill and a ¹⁄₁₆-inch bit (it's very small!)
- 26-gauge floral wire
- Card stock in any colors you like. Make sure it's lightweight; if you use heavy card or paper, you will need a thicker wire.
- Scissors
- Pencil
- Awl or needle
- Glue (tacky or other white glue)
- Wire cutters
- Binder clips or clothespins
- Optional: paint

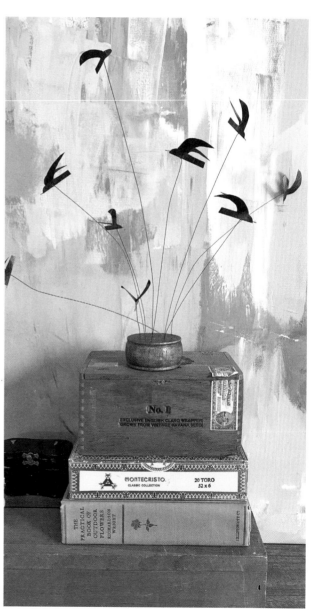

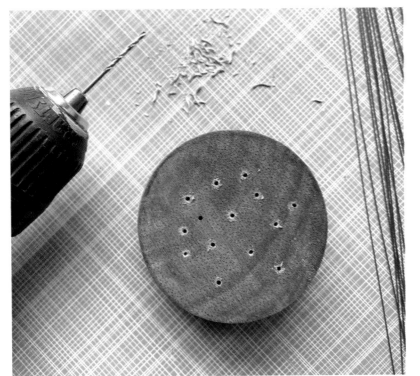

Step 1

Drill a bunch of holes in your wood block. No need to do it in any sort of pattern—go about ½ inch down, and drill at least nine holes. You can add more later if you want a fuller murmuration. Brush off the wood bits.

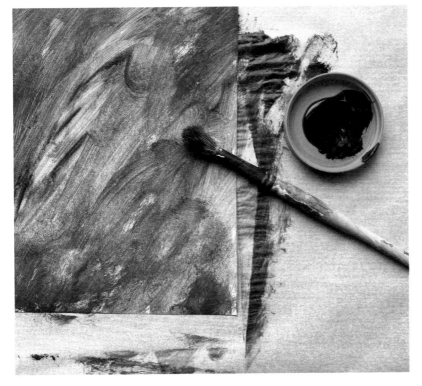

Step 2

If you are painting your card stock, do it now. I want my birds to be textured and dark, so I've painted both sides of the card stock, letting it dry between sides.

I've painted two pieces of card. It might be too much, but it's better to have extra than not enough!

Step 3

Fold the card and use a template to trace the bird shape, as shown.

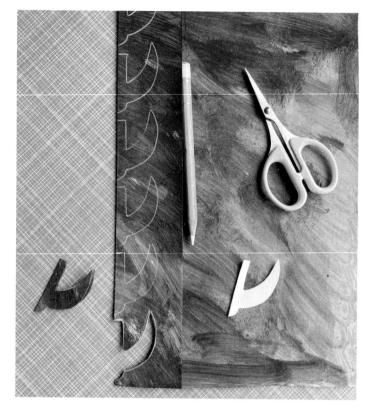

Step 4

Repeat as many times as you like and cut out all the birds.

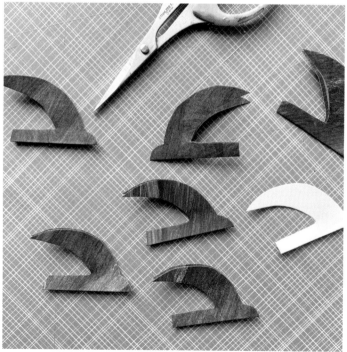

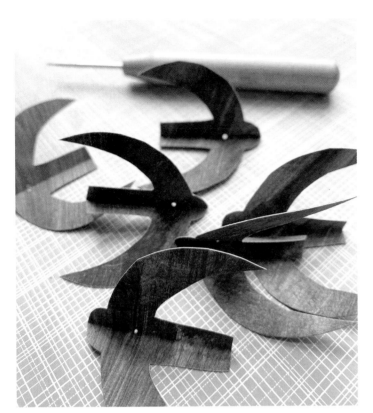

Step 5

Now take an awl or needle and poke a hole in the fold between the wings of each bird.

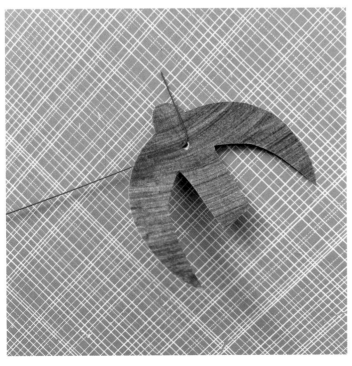

Step 6

Grab a piece of wire and bend it at the top, about 1 inch down. Insert the wire through the hole inside the fold, and pull it down to the bend of the wire. Position the smaller bend of the wire so it sticks out like a beak from the bird's head.

Step 7

Add a small line of glue on the inside of the fold, along the body but not on the wings. Use a clip to hold it together until it dries.

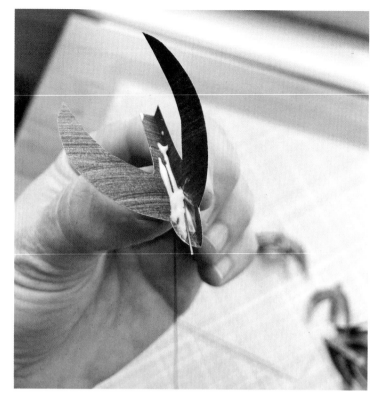

Step 8

Repeat with all of the birds!

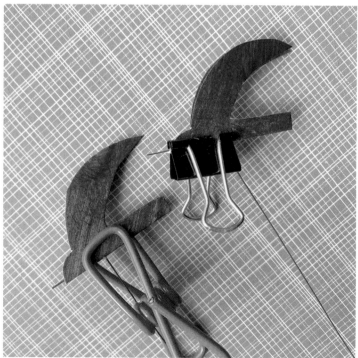

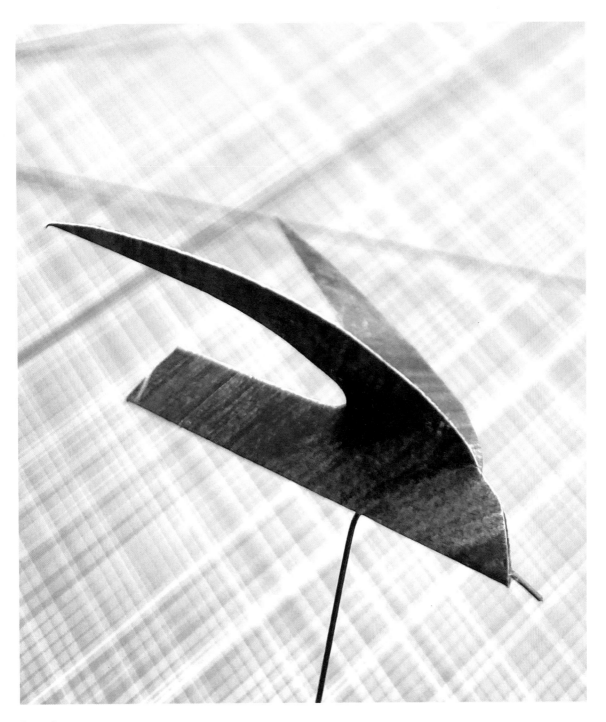

Step 9

When the birds are dry, remove the clips and carefully fold down the wings as shown. If the beak wire is too long, trim it with wire cutters.

Step 10

Now that you have a bouquet of birds on wires, you can start arranging them in your wood block.

Cut the wires to different lengths, one at a time, as you arrange the birds. Make an arrangement featuring a variety of heights.

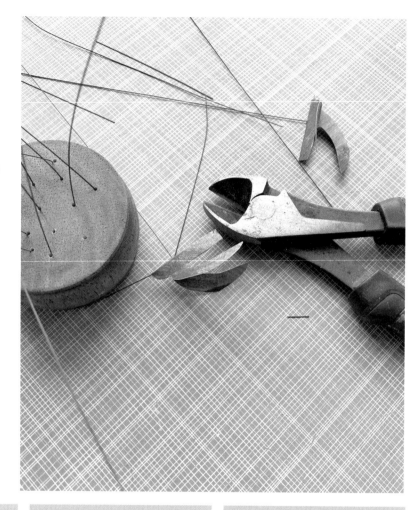

If the birds make the wire droop over too much, you probably need to trim the length of the wire.

You can lightly curve the wires if you like that look.

Don't glue the wires in the block. This allows the birds to move and swoop and turn in a breeze.

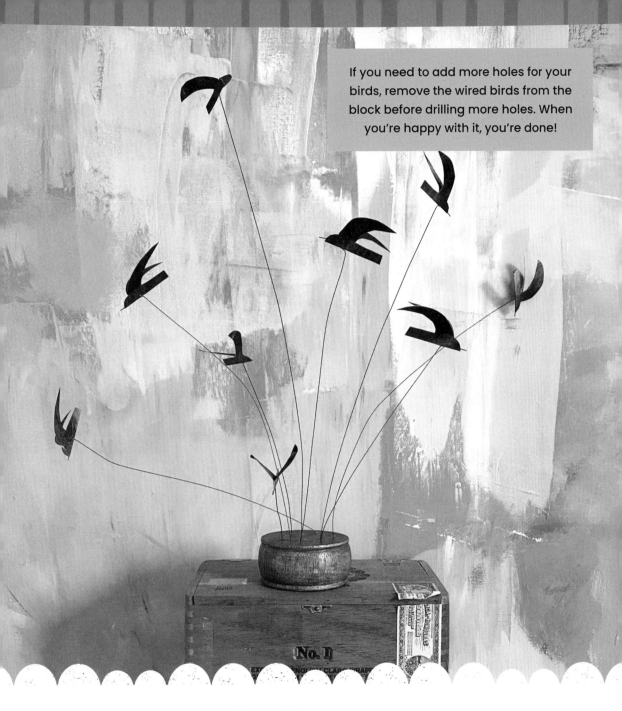

If you need to add more holes for your birds, remove the wired birds from the block before drilling more holes. When you're happy with it, you're done!

No. 1

TRY THIS TOO!

If you want, experiment with other creatures. This project would look lovely with butterflies or moths!

DIORAMA

Dioramas always delighted me as a kid. Usually, they'd be in an activity book, and the shapes would be precut. All you had to do was bend them so that they stood up, and suddenly a whole little world would appear! It was just so clever.

I've adapted this into a DIY project. You get to design the whole thing, draw and color it, and cut around the characters and scenery. Once you've finished, you can bend it back down, slide it into an envelope, and send it to a friend. Of course, you can always keep it for yourself. Nobody would blame you!

TOOLS & MATERIALS

- Two pieces of card stock, Bristol paper, or watercolor paper—anything somewhat thick and strong
- Paper
- Ruler
- Pencil
- Craft knife
- Scissors
- Supplies for decorating (your choice!): paint, colored pencils, paint pens, crayons, or markers
- Glue stick

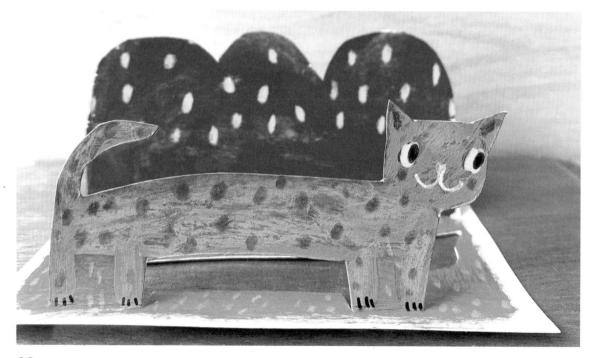

Let's Go!

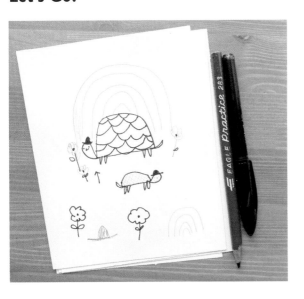

Step 1

First of all, consider the type of scene you'd like to make. Dioramas have depth, so you'll want to consider a background, middle ground, and foreground. You can use some photo references if you like. I've chosen to make a turtle in front of a rainbow, and I've used my imagination to draw it.

Use scratch paper to make some drawings of any character, scenery, flora, or fauna that you'd like to add, so you have a collection of images from which to choose.

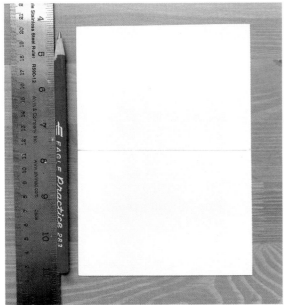

Step 2

Grab a piece of card stock or other stiff paper (any size will do), a ruler, and a pencil. Mark the halfway point on the paper and draw a line across.

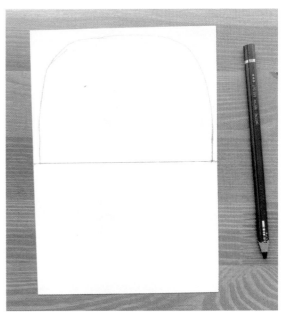

Step 3

The background should take up half of the paper, so it can stand tall enough to show over the other cut-out elements in the foreground. Mine is a rainbow, and you can see I'm leaving a small margin around the edges of the paper—about ¼ inch or so.

Step 4

On the other half of the paper, begin drawing your design. I've chosen a focal point of a turtle wearing a hat surrounded by colorful flowers. You will be cutting out each detail, so make sure to leave room around the edges. Consider placing the images at different depths to give the scene a dynamic feeling.

Step 5

When you're happy with the scene, add color! Keep it sparse and minimal if that's your style, or colorful and bursting with things if you prefer! You can draw, color, paint—any way you like to decorate.

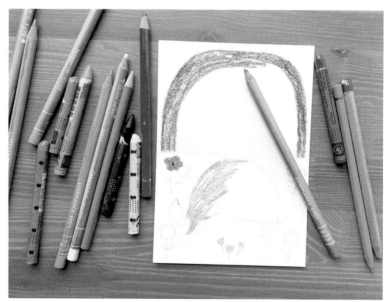

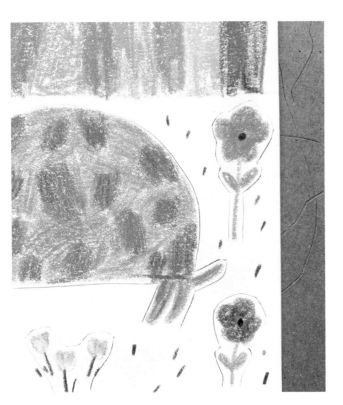

Step 6

Once you are pleased with your design, it's time to cut around the images. Using a craft knife with a fresh blade, carefully cut around each item. Use a thick piece of cardboard or a cutting mat under your artwork to protect your surface when cutting. Be careful, and do not cut the whole thing out. Leave the base connected to the paper so you can fold it up! Keep the items down after they're all cut out.

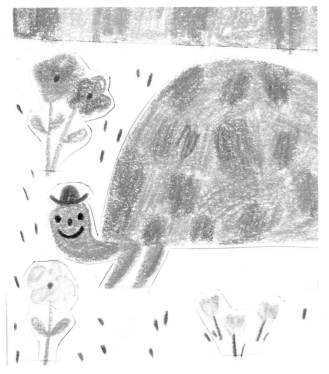

Step 7

All of the components in your scene will have a base—this is the part at the bottom of each thing that you didn't cut. You will fold up from the base to make the items stand. It's helpful to score the bases before standing them up. Use a ruler as a guide and run a butter knife along the base of each component separately. This simple step makes the fold clean and sharp.

Step 8

Once scored, carefully fold the items up to a standing position. How cute is that?!

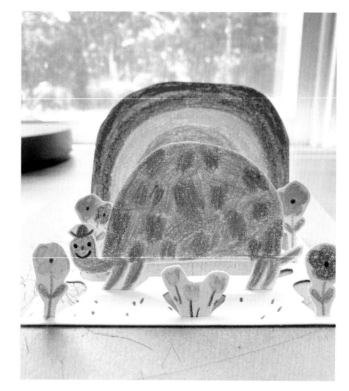

Step 9

To finish the diorama and make it a bit sturdier, carefully apply glue (I would not use anything besides a glue stick or the paper will wrinkle and bubble) over the entire back except in the bent-up areas. Stick it down onto another piece of card stock. Smooth it gently on the back with your hands.

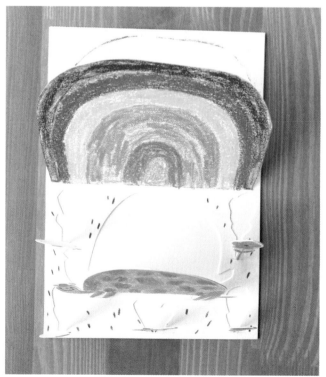

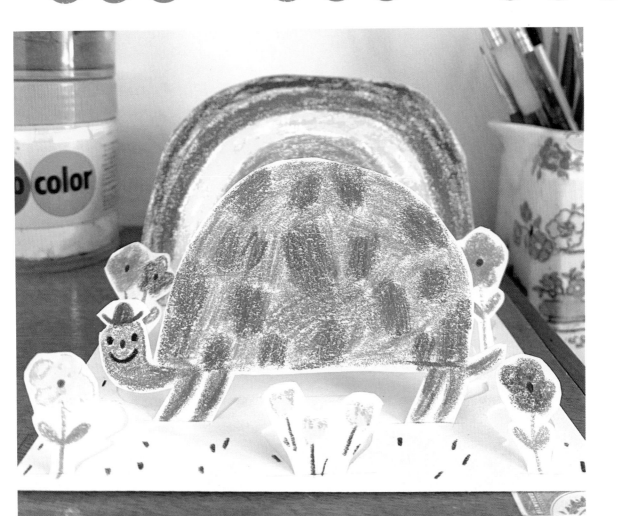

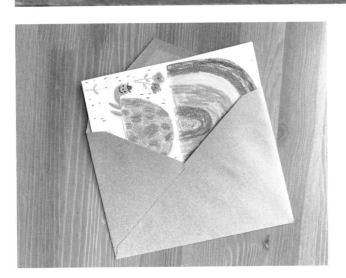

Voilà!

If you want to send this to a friend, you can push the popped-up stuff back down and slide the diorama into an envelope.

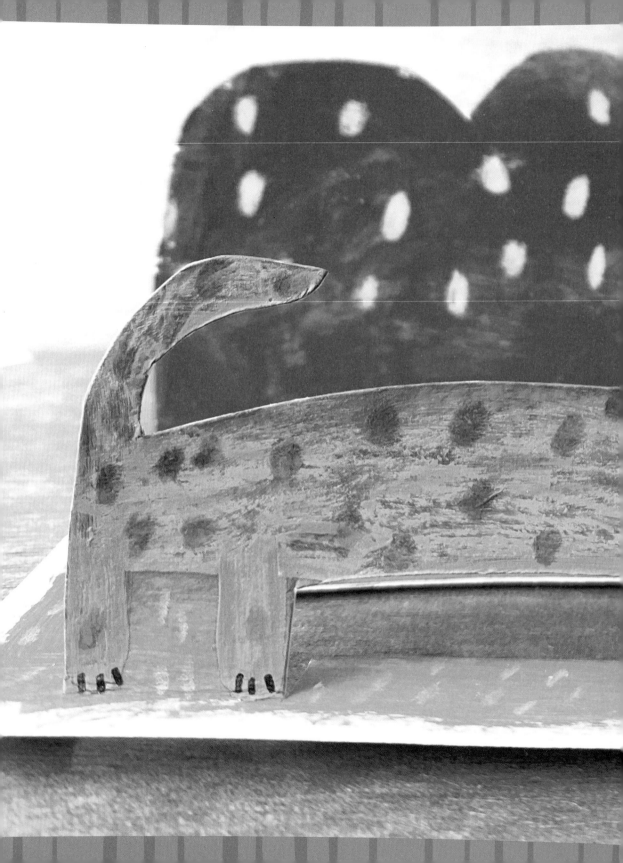

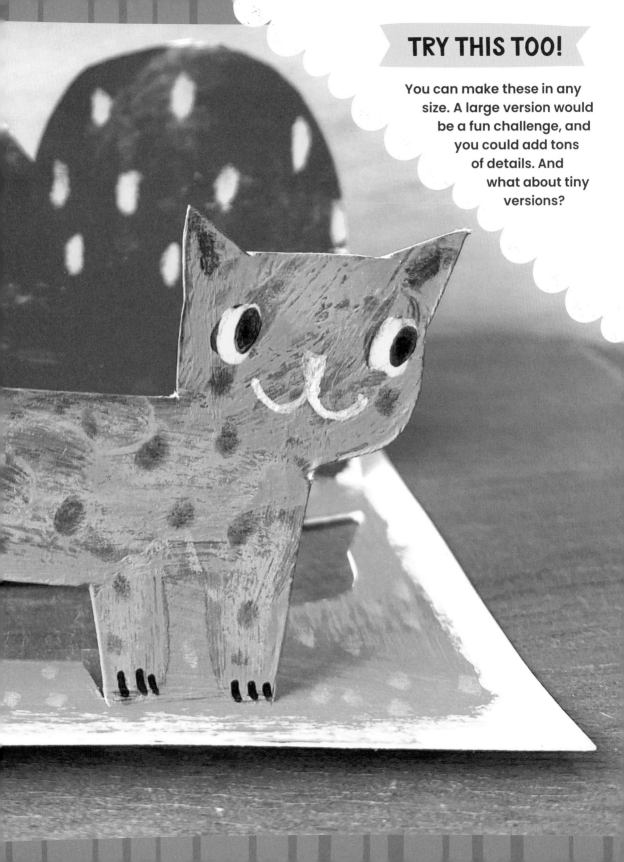

TRY THIS TOO!

You can make these in any size. A large version would be a fun challenge, and you could add tons of details. And what about tiny versions?

PAPER TAPE STICKERS

Lately I've been on a real kick of making stickers from paper tape. It's easy and fun, not too messy, and very inexpensive—and eco-friendly, unlike many vinyl and plastic stickers! Who doesn't love stickers?! Making them yourself means you can customize them exactly the way you want. Subject, color, shape...it's up to you!

TOOLS & MATERIALS

- Water-activated paper tape (see "Tools & Materials" on page 10)
- Small, sharp scissors
- Craft knife
- Masking tape

Options for decorating:
- Permanent markers
- Colored pencils
- Acrylic paint pens

- Acrylic paint (white or colorful)
- Matte medium
- Rubber stamps
- Paper

After playing around with this idea for a while, I've found many ways to approach making stickers, from super-duper simple to a little more involved. I'll show you a handful of ways to work with paper tape stickers, but I bet you'll figure out some new ways to use this idea too!

Always be careful to keep the back of the tape dry. The sticky part is water-activated.

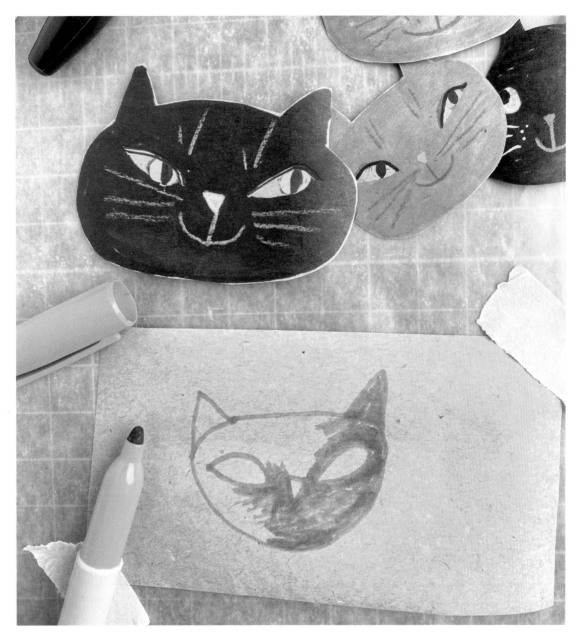

Prepare your tape by cutting off a strip; 8 inches at a time works well. Use masking tape to attach the ends to your work surface to keep the tape from moving around while you work. I do this step every time—it makes it easier.

Permanent Markers

This is as simple as drawing your picture with markers! Use one color or all the colors, and draw. Try different line thicknesses and color parts in...whatever makes you happy! You can lightly draw your designs with pencil if you feel more comfortable. Once you're happy with your stickers, simply cut them out. Small, sharp scissors are best.

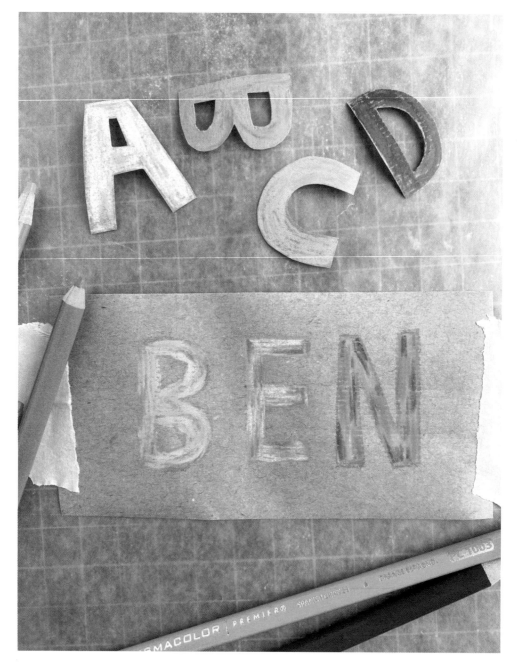

Colored Pencils

You can use colored pencils for stickers too! In this example, I've made letters that I'm going to add to a wrapped present. I love to vary the lights and darks of the same color to give my letters some "oomph." You can add color to the permanent marker stickers with colored pencils too. Make sure to get a nice, thick layer.

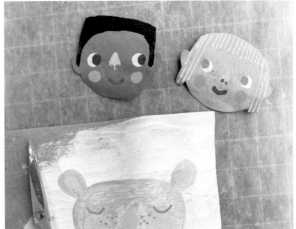

Paint & Paint Pens

This method is a little more complicated, but worth it. Acrylic paint pens are my favorite tool for making stickers. They come in so many colors, the paint is vibrant and opaque, and they're easy to control!

You can draw and color directly on the tape if you like. But I have found that the tape pills as the paper gets saturated with color. My suggestion is to either use a light touch to avoid that, or use the matte-medium technique.

Matte Medium or White Acrylic Craft Paint

You can use either of these to make a base layer upon which to use paint and paint pens. The medium creates a barrier and protects the paper from getting too wet from ink.

Step 1

Simply brush a very thin layer of matte medium across your taped-down paper tape and let it dry. You can also use acrylic paint if you'd like a different colored base for your sticker. Make sure it's really dry. The tape might curl a little, but it flattens out as it dries.

Step 2

Then draw with paint pens or paint with paints and a brush to make your sticker images. The great thing about painted stickers is how many layers of color you can add. Let the paint dry between each layer.

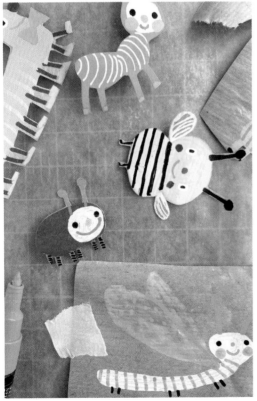

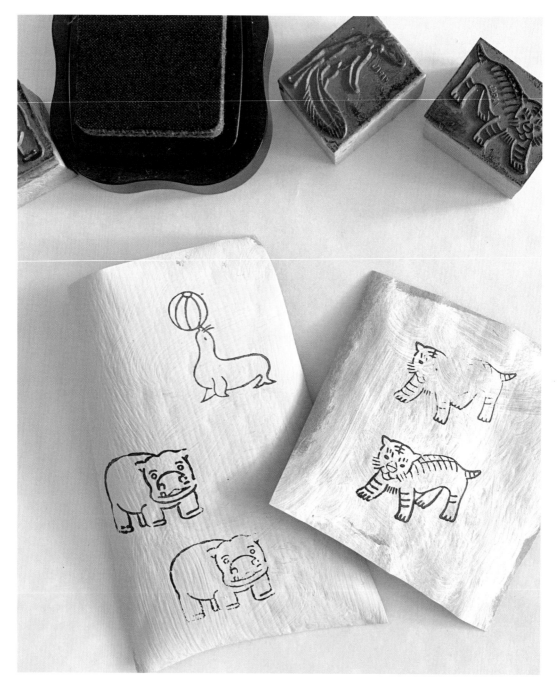

Rubber Stamps

If you don't feel super comfortable drawing and painting, you can also use rubber stamps to make stickers. I recommend using a permanent ink pad to avoid smearing. You can color in the stamps too!

Collage Papers

Here's a variation to consider! I enjoy collaging with brightly painted and textured papers. By giving lengths of tape a quick scrub of various colors of acrylic paint, you end up with small, easy-to-transport bits of colored paper. No glue needed; just add a dab of water when you want to do some collaging.

Making stickers could not be easier! It's a great rainy day activity, or something to do with your hands while watching TV. You'll end up with a pile of stickers in no time.

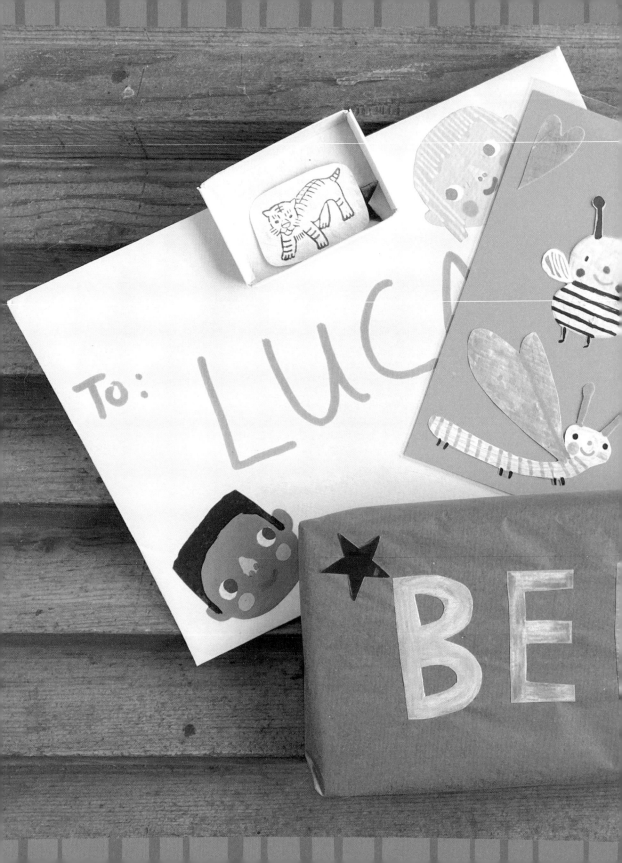

TRY THIS TOO!

Now how will you use all these stickers? Maybe you want to:

• Add them to envelopes and boxes for fun mail.

• Package a little collection up for a friend. Create a theme around their interests, such as dinosaurs, cats, food, and so on.

• Use them in a planner to mark special days.

• Put them on notebooks to make the covers a little more interesting.

What else can you think of?

HIGH-FIVE POP-UP CARD

Allow me to introduce you to the high-five card! I made this for a nephew, and he really liked it. This is a happy thing to send to anyone. The way it opens is a surprise, and it urges interaction (you have to high five back!), which makes it extra fun! The folding technique is called a Turkish map fold, and it is used by many book artists. It's not difficult, but it takes a little precision and patience at first. I suggest practicing the fold on blank paper until you feel comfortable. Once you've mastered the fold, you can make the rest of the card with just a few materials. Send it off to a pal and you'll be sure to make their day!

TOOLS & MATERIALS

- Paper: square, any size (8.5" x 8.5" makes a good card size)
- Card stock, cut to 8.5" x 4.25"
- Markers or colored pencils
- Glue stick
- Scissors

- Scraps of colorful paper or bits of painted paper tape
- Ruler and craft knife, or a paper cutter
- An envelope to fit your card (if sending in the mail)
- Optional: photocopies of your hand
- Optional: bone folder

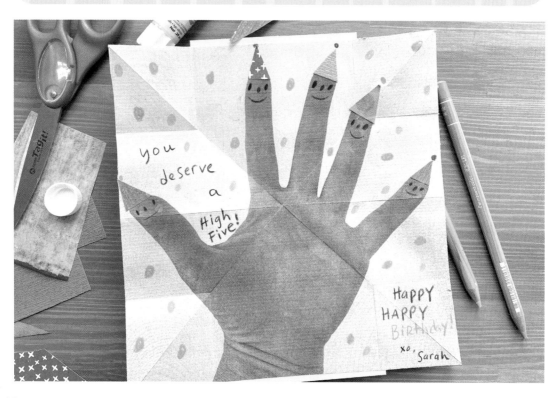

Fold

Step 1

Begin with your paper image-side down, fold it in half, and crease well with a bone folder or a capped marker.

Step 2

Open it back up.

Step 3

Turn the paper image-side up and fold diagonally one way. Crease well.

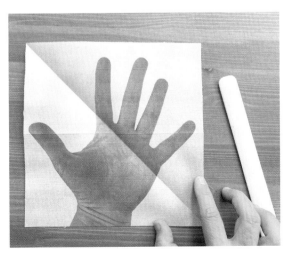

Step 4

Open it back up and fold diagonally from the other corner. Crease well.

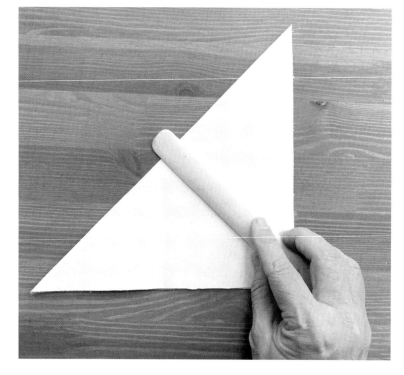

Step 5

Open it back up and turn it over (image-side down again).

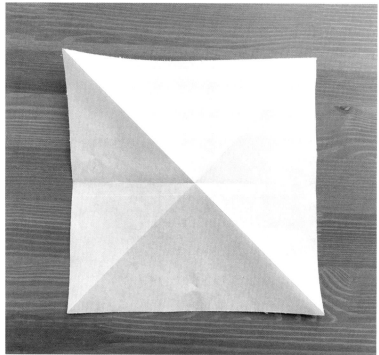

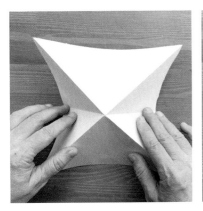 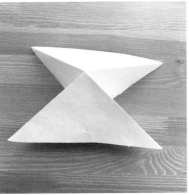 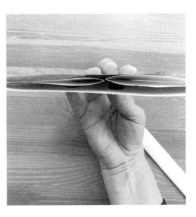

Step 6

Position your paper so it looks like the photo. Using your fingers to guide, push the creased triangles in and flatten, as shown.

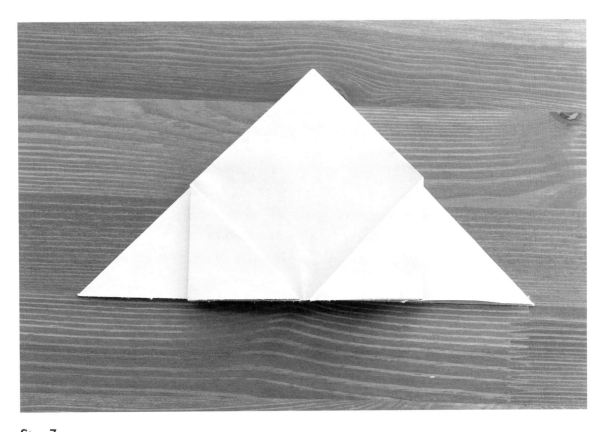

Step 7

Fold in the right and left points to the center, as shown, and crease very well.

Step 8

Turn over and fold the points to the middle, and crease well.

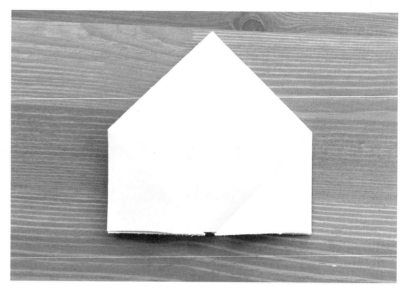

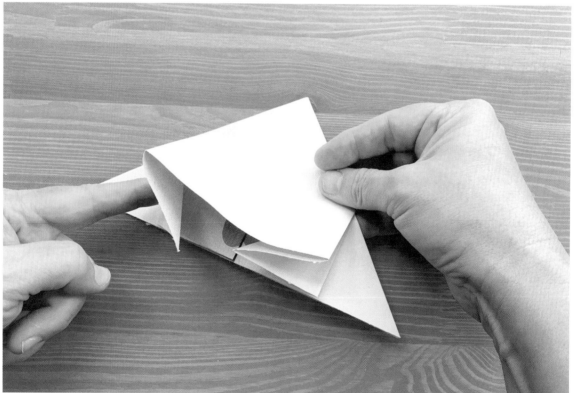

Step 9

Now turn each point to the inside by pushing the crease until it spreads the folded paper. Keep gently pushing on the crease until it goes all the way in (it sort of turns itself inside out).

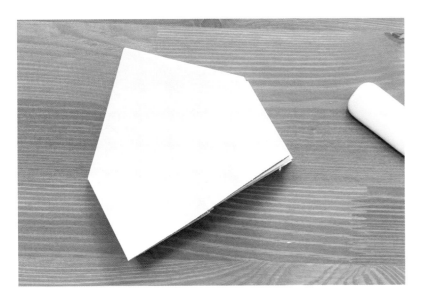

Step 10

Repeat with the remaining three points until your paper looks like the photo.

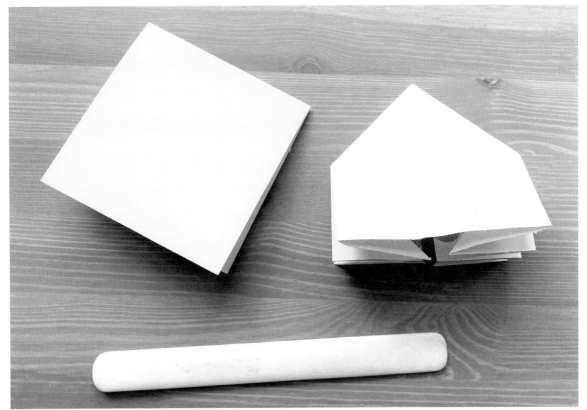

Step 11

Once you have it folded, with the image on the inside, you're ready to attach the card cover.
Fold your card stock in half.

Step 12

Spread glue on the back area of the folded paper as shown, and stick it to the inside back of the folded card. Make sure the point of the folded paper is right next to the crease.

Step 13

Now spread glue on the side of the paper facing up and close the card on top of it, rubbing to stick well. Let it dry—you can even flatten it by putting a heavy book on top.

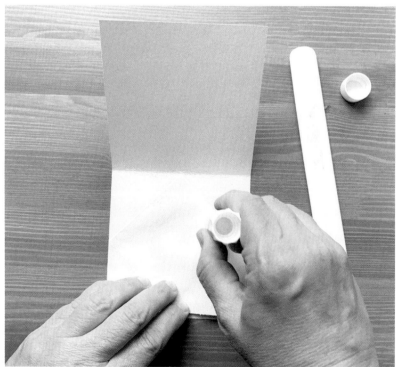

Decorate the Card

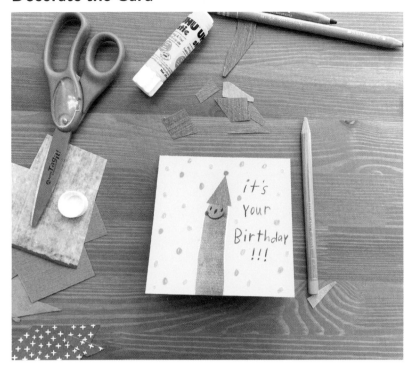

Step 1

For the cover, use a second photocopy of your hand to cut out one finger.

You can make a funny character by drawing a silly face (see "Finding Faces" on page 12 for inspiration) and adding a party hat made from a scrap of colorful paper.

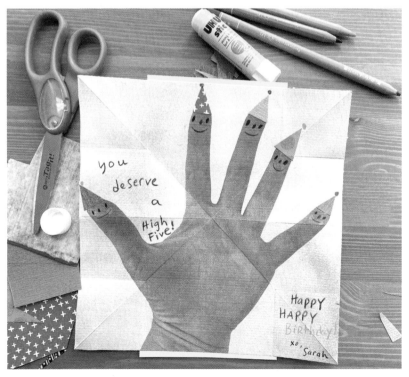

Step 2

Inside, continue the theme by drawing faces on all the fingers and adding party hats to each one (see "Making Hats" on page 13). You can write a message inside too!

Step 3

Add more flair with colored pencils or markers.

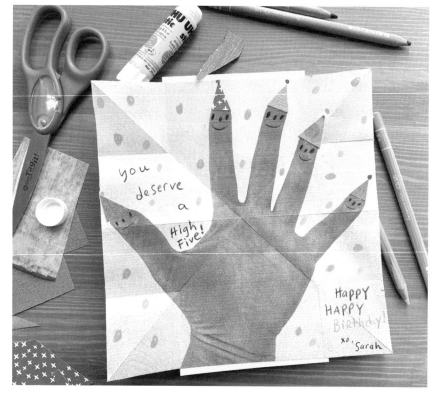

Step 4

Try out the card by folding it closed and then opening it up. Isn't that cool? It starts as a small card and then becomes bigger when it pops open. Surprise!

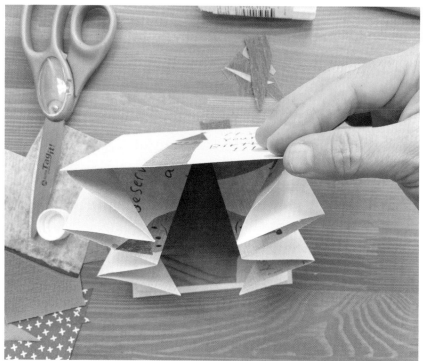

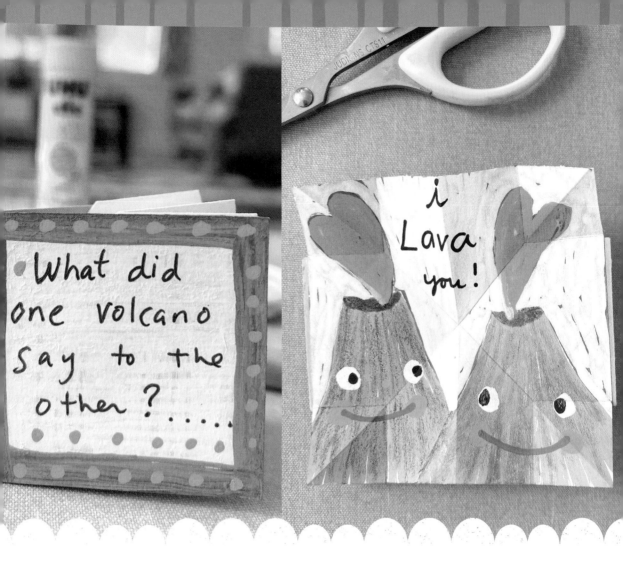

What did one volcano say to the other?

i Lava you!

TRY THIS TOO!

Another super-fun thing to do with these cards is to make them small jokes.
The cover sets it up, and the inside pops out the punchline!
Here's a teeny joke card I made for a friend.

What other ways could you make this project your own? Have fun with it!

FINGER PUPPETS WITH STANDS

I love puppets and will never outgrow them. This project is inspired by a darling finger puppet my aunt gave me many years ago. I loved that it came with its own stand, which made it so much easier to display.

In this project, I'll teach you one of my favorite techniques: paper-tape cheater papier-mâché. While I love the mess of a papier-mâché project, sometimes I want a super-easy setup and cleanup. Cheater papier-mâché does the trick. These puppets are quick, fun, and use a lot of recycled materials and scraps of paper and fabric. The addition of the stand makes them fun to display and present.

TOOLS & MATERIALS

- Paper tape
- Newspaper or other paper scraps
- Masking tape
- Hot glue gun
- Thin cardboard
- Craft knife
- Cup of water

- Paint and paintbrush
- Paint markers
- Scraps of fabric, decorative paper, and trim
- Tacky glue

- Wood slices or blocks (You can also use the cardboard stands from "Pipe Cleaner Buddies" on pages 80-89)
- Drill, if using wood blocks
- Optional: wax paper

Cheater Papier-Mâché Heads

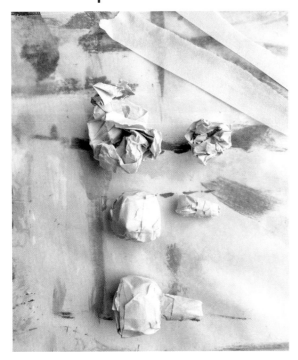

Step 1

I like to keep these heads simple. In this example, I'm making a little pig, so I'll be adding a snout.

Crumple a little bit of newspaper in the shape of a head. Hold it in place by wrapping strips of masking tape around it. To make a snout, crumple a smaller piece of paper into a snout shape and tape it to secure. Hot glue it to the head.

Step 2

To make the neck, cut a piece of thin cardboard and wrap it around your finger—not too tight or too loose. Overlap the edges and tape it.

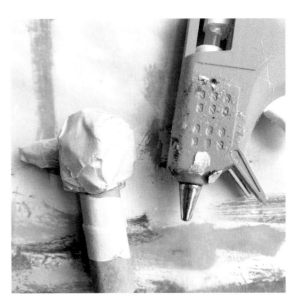

Step 3

Hot glue the tube to the bottom of the head by putting a blob of hot glue on the bottom of the head and squishing the tube into the glue until it dries.

Get Ready to Papier-Mâché!

Step 1

Tear up a bunch of thin strips of paper tape. To make papier-mâché, grab a tape strip and using the paintbrush, paint water on the non-gummed side first. Then flip it and brush water on the gummed side.

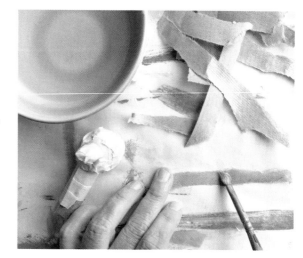

Step 2

Smooth the strip onto the head, pinching and squishing it to adhere. It will look like a soggy mess at first, but just keep going! Continue with more strips all the way around the head until it is covered with a solid, overlapping layer of wet paper tape strips. Make sure to cover the tube too! If necessary, tear little bits of tape to patch any holes.

Note: I like my heads to be a little imperfect and rough-looking. If that's not your bag, you can be more meticulous with your tape-mâché!

Then let it dry completely—overnight is best. The heads should be fairly hard when they're dry.

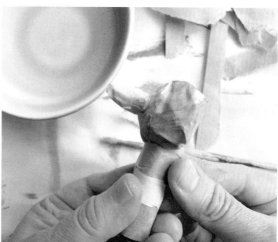

Step 3

To add easy ears, cut out two ear shapes from thin cardboard. Use a craft knife to slice into the papier-mâché head where each ear will go.

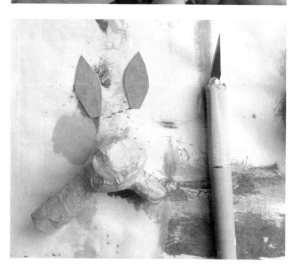

Step 4

Blob some glue (hot or tacky) over the sliced area and put the ear into the spot that you sliced. Let it dry completely.

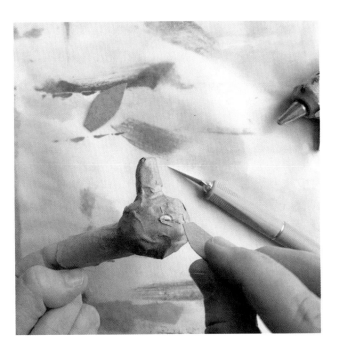

Step 5

Now it's time to paint! You can prime the heads with gesso or white acrylic paint if you like, or jump right into painting. I've painted my piggy a light pink and used paint pens to add eyes and other details. Let the paint dry, of course!

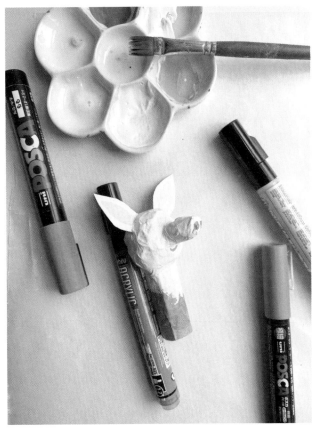

Dress Them Up!

Let's dress these guys! I find that it's more fun to have a heap of scraps to play around with for clothes rather than planning it out first. Pile up your scraps and bits, and you'll see!

Gather your favorite scraps of fabric. This is the perfect place to use special little bits that you've been hoarding.

Then cut some strips of fabric. I like my strips to completely cover the finger tube, so I usually cut them a bit longer than the tube. Make sure the strips of fabric will wrap at least once around the tube, with a little overlap for gluing.

If you have decorative paper on hand, you can use it the same way as fabric. Cut the strips to fit.

You can also use cupcake wrappers. They come in lots of neat patterns and colors, and you can cut segments of the pleated part to wrap around your puppet to make clothes that flare out.

Put a line of glue around the tube under the head, on the neck. Wrap your strip of fabric or paper around the tube until it overlaps. (I like to put the overlap on the back of the puppet.) Let it dry!

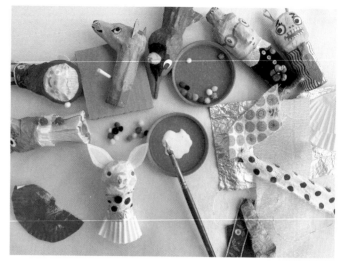

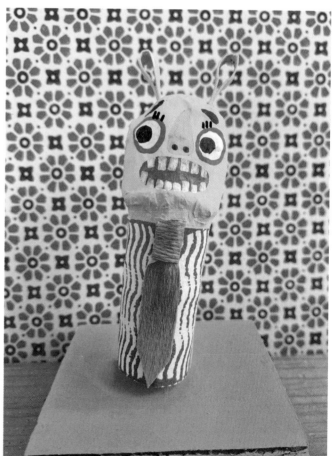

Don't Forget Hats!

Try adding a festive party hat (see "Making Hats" on page 13 for inspiration). Use glue to add any extra bits of trim or decoration. Pom-poms, ribbon, crepe paper—anything you have!

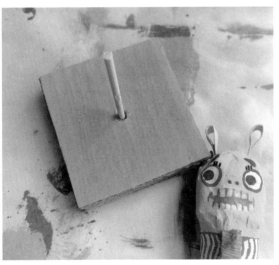

Make the Stand

Step 1

Now that you've got a finger puppet (or 10...), let's make a stand for a super-cute presentation.

You can approach this two ways. Either follow the instructions on pages 86-87 from "Pipe Cleaner Buddies" to make a glued, painted cardboard stand. Or make a wooden stand by following these directions.

Step 2

Grab a wood slice, block, or chunk. You can even cut your own if you're handy with a saw.

Get a bamboo skewer or dowel—any size is fine as long as it will fit in your puppet tube, and you have a drill bit in the correct size. Check how long it needs to be by putting your finger puppet on the skewer and adding ½ inch for inserting into the base. More is better; you can always trim it down if it makes your puppet sit too high. I like the puppet to sit on the stand without the dowel showing.

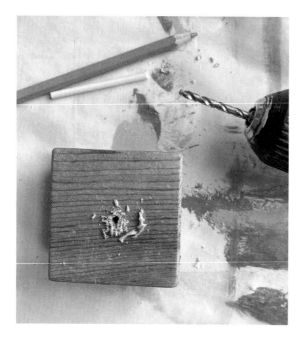

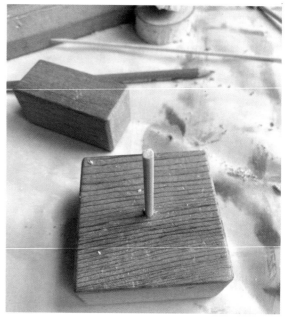

Step 3

Make a mark in the center of the wood you're using for the base. Hold it firmly with one hand and drill a hole with the other. Make sure you don't drill all the way through; it's very easy to do!

Step 4

Fit the skewer into the hole you drilled. You can make it permanent by putting a little tacky glue in the hole and replacing the skewer. Wipe any excess glue that spurts out. You can leave your stand plain, or paint and decorate it!

Step 5

Once everything has dried, you can pop your finger puppet on the skewer. Isn't it cute?

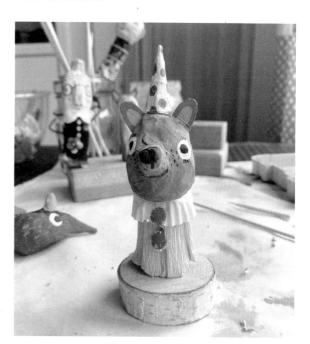

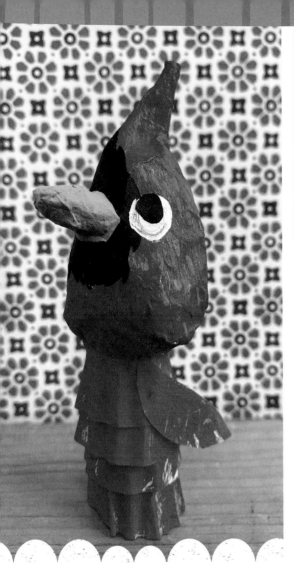
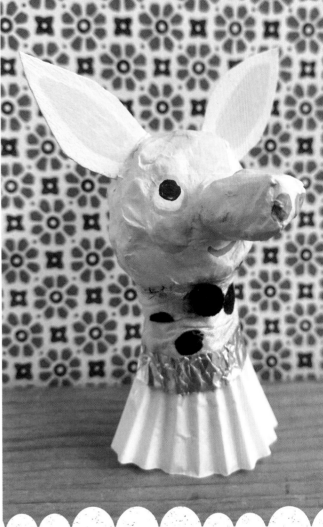

TRY THIS TOO!

What else will you make? How about...

- A cast of characters from a favorite story?

- A special pet-portrait puppet for a friend?

- A nonsense character?

- Your family?

ARTICULATED DOLLS & CREATURES

Articulated character is just another term for a character with moving arms and legs, or joints. The approach to the figures in this section is dear to me. I've been making articulated figures for years. It's addictive, it's inexpensive, and the results have a rough-hewn charm. You can channel your inner kindergartner and get super messy with paint, or you can be extremely precise and careful with a craft knife or box cutter. You can use your imagination and make big or small cardboard friends. This project is more of a suggestion to get you started. I've included lots of examples so you can see the possibilities.

You don't need much in the way of supplies, so there aren't many barriers to getting right down to playing. If you do this project with kids, cut out their figures for them.

TOOLS & MATERIALS

- Corrugated cardboard
- Box cutter or craft knife
- Scissors
- Paint and paintbrushes
- Paint pens
- Brads or paper fasteners (the bigger kind from the office store work best with corrugated cardboard)
- Tacky or hot glue
- A pipe cleaner or piece of yarn
- Optional: painted paper tape
- Optional: pipe cleaners

Step 1

My favorite way to approach this project is painting a handful of corrugated cardboard pieces (such as the flaps from boxes or any non-folded bits) and finding inspiration once I have a few colors.

Squeeze some paint onto a piece of cardboard, and quickly spread it around with a big brush. You can mix colors directly on the cardboard if you want. Just add multiple colors and mix with a brush until you like the way it looks. Let the paint dry completely.

I liked this orange cardboard, and it made me want to make a tiger!

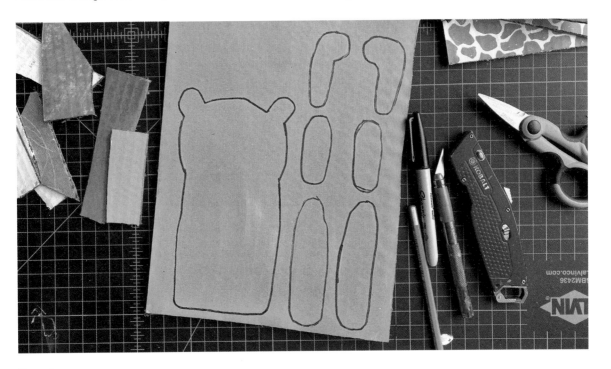

Step 2

Draw your design on the cardboard. I've used a permanent marker, but feel free to use a pencil with an eraser if you prefer.

Draw the body and the head as one shape. The legs are their own separate shapes. I want the arms to bend at the elbow, so I have two upper arms and two lower arms.

Step 3

Leave a generous ¼-inch margin around the spot where you will make a hole to join the body parts.

This is a great place to use your painted paper tape too. You can collage onto your figure for extra pops of color.

Step 4

Using paint pens or paint, add details and extra texture, fur, clothes—whatever your character calls for!

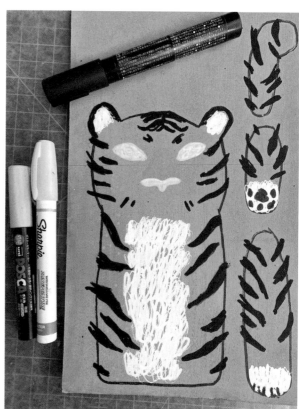

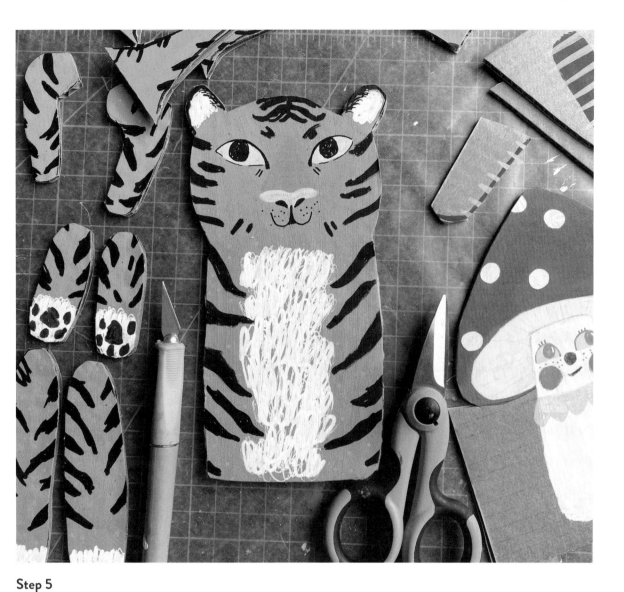

Step 5

Let the paint dry completely; then cut the body parts out carefully and safely using a craft knife or box cutter. You may need scissors for small areas.

Another approach is to completely plan out and then draw and paint your design directly on the cardboard. I made a mushroom friend this way.

How to Attach

Brads (also called paper fasteners) are traditionally used to attach limbs on articulated dolls. Make sure to maintain a margin on the edges, so the cardboard doesn't rip from the stress of moving the limbs.

Step 1

Poke holes with something sharp (I've used the tip of my craft knife) in the main body where you want to attach the limbs.

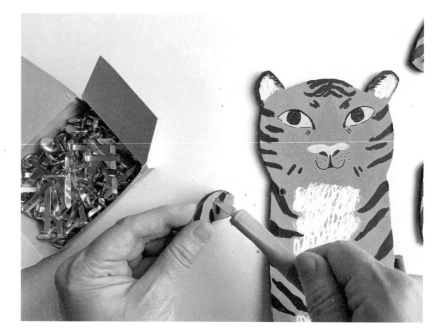

Step 2

Place the limb behind the main body and use a pointy pencil to mark through the hole you made. Once you have it marked, make a hole in the limb.

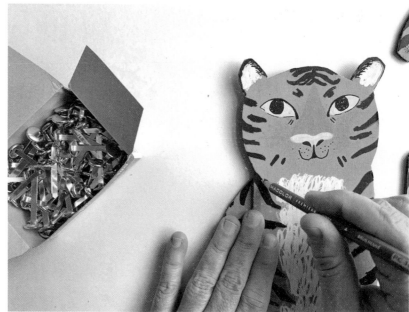

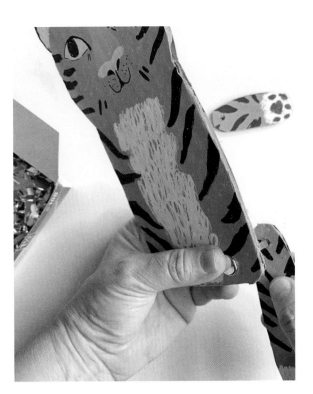

Step 3

After making all the holes, layer the limbs and body and insert the brads through the holes. Bend back the prongs on the brads to secure.

I've used super-long brads, so I bent the prongs back double so they wouldn't show.

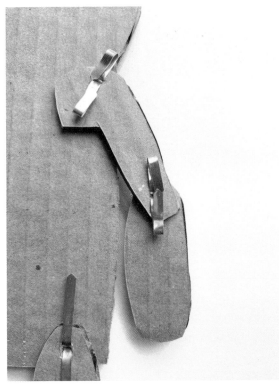

Make sure there's enough slack to position the limbs, but not so much that they move back after you've posed your character.

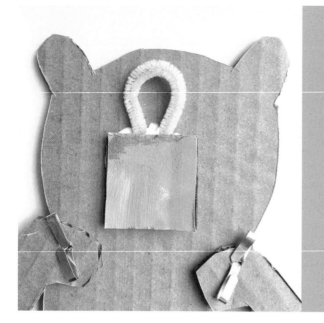

These characters look so fun hanging up! Here's how to do that.

Grab a piece of a pipe cleaner or yarn. Blob some glue—hot or tacky—on the back of the creature. Press the loop of pipe cleaner or yarn into the glue. Use a scrap of cardboard to sandwich the yarn ends. Let it dry completely. Now you're ready to hang up your character, or wrap it up and give it to someone!

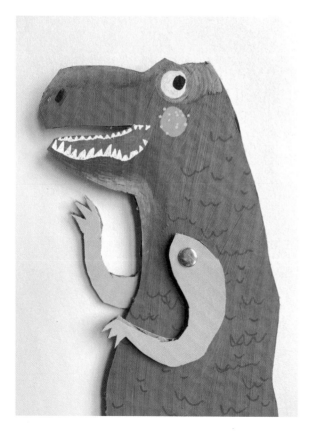

You can use scraps of painted cardboard to cut out shoes and other little details. Use hot or tacky glue to attach.

Look at this cute little guy!

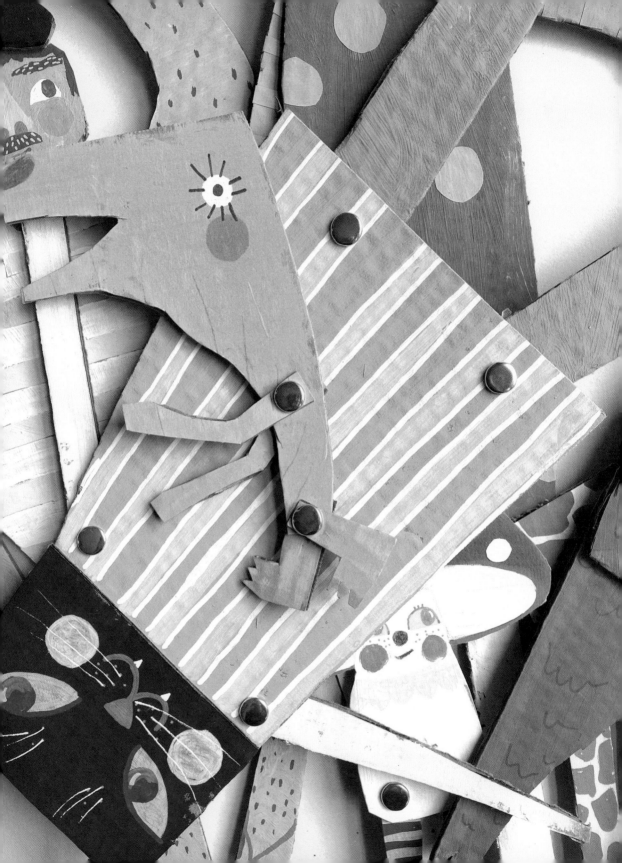

MOOD BOOK

This is a fun, quick project that explores two sides of the same coin: happy/sad, up/down, open/closed...you get the picture! I call this structure a book, but you could think of it as a card too. Either way, it's a cool, easy-to-make, interactive piece of art.

TOOLS & MATERIALS

- Card stock or Bristol paper in any color. Experiment with what you have! Manila folders are a great weight. Make sure that whatever you choose will take the media with which you decide to work.
- Masking tape (a good-quality brand so it sticks well)

- Ruler and craft knife or scissors
- Cutting mat or piece of thick cardboard (the backing on a sketchbook, for example)
- Acrylic paint, paint pens, colored pencils, markers—whatever you like to draw or paint with.

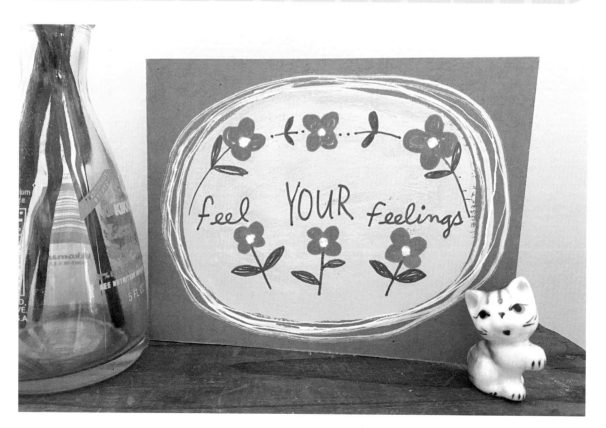

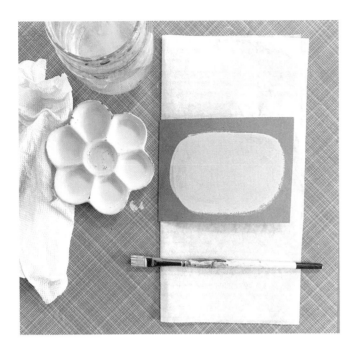

Step 1

Decide what size your book will be and cut and fold the cover. Mine is 5.5" x 4.25".

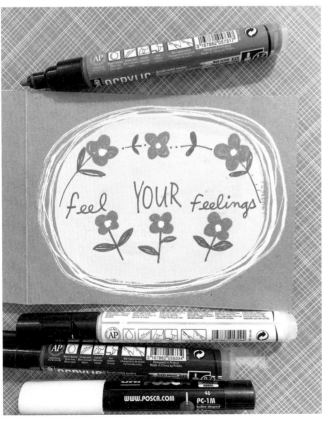

Step 2

My book is a mood indicator of sorts, and I've decided to call it "Feel Your Feelings." Decide on your theme and add text to the cover, as well as any other decorations you want.

Step 3

Cut 10 strips of light-colored card stock to about 1 inch wide.

Open the cover. On the right side, begin taping your strips down from right to left.

Line up a strip on the vertical edge and the top-horizontal edge. Don't worry about the strips hanging off the top and bottom; you'll trim them at the end. Tape and rub it down well.

Step 4

Overlap the next strip by about half and tape. My strips are woefully crooked. It's OK; it'll still work. Try not to get too bogged down in precision.

Step 5

Continue until you get to the fold. Using a ruler and craft knife, trim the excess tape and paper from the edges.

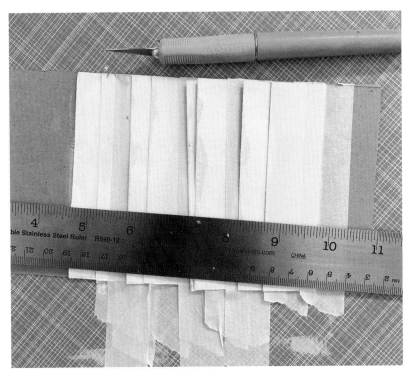

Step 6

Now flip the taped pages to the right and tape the other sides of each strip, one at a time. You're making a strong hinge sort of thing for each strip. Trim the tape.

Add Imagery

Step 1

I'm making a person who is smiling when the book is flipped one way and frowning when the book is flipped the other way. First, I'll make a smiling face. I'm keeping it simple and sort of easy because I'll have to draw most of it again when I flip it!

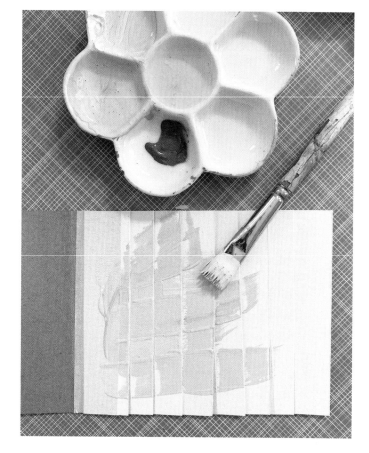

Step 2

I'm using acrylic paint and painting the background first. Make sure all sides of your hinged strips are painted. As you can see, I'm using a light touch with the paint, so it doesn't seep down and stick the strips together. The hinged strips can be positioned so they're sort of standing up, which helps them dry without sticking to each other.

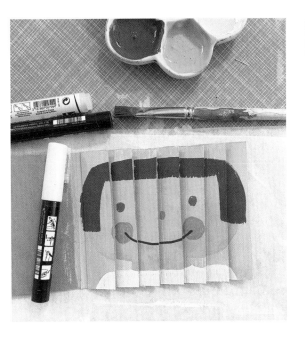

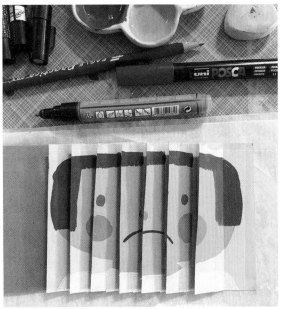

Step 3

Now the face! With the pages flipped to the right, draw an image (such as a face), and then paint it. Let it dry completely if you're painting, or use another medium like colored pencils or markers.

Step 4

Now that it's dry, flip the pages to the left. Then draw and paint your image again as similarly as possible to the first one, except for whatever you're changing. For example, my face was smiling on the first side, but now I'm making it frown.

Once your little book is dry, you can close the cover and press it under a heavy book if you like. Then open it and flip the pages back and forth. How fun is that? It's like very simple animation!

TRY THIS TOO!

What else can you do with this idea? A thumbs up and a thumbs down? Blinking eyes? A mouth opening and closing? I bet you can dream up some great ideas!

PIPE CLEANER BUDDIES

Pipe cleaners, chenille stems, fuzzy sticks, bendy wires—whatever you call them, you've probably spent some time with them in your life. I always have some on hand for craft projects or to entertain visiting kids, but I've never been a real fan of pipe cleaner crafts. Turns out, I was wrong!

One day, I found myself fiddling with some brightly colored pipe cleaners I had left over from a class I'd taught, and I made a little figure—just the body of a person—out of twisted and rolled chenille. It was like childhood came rushing back! Well, that was fun! Within a few minutes, I had a small heap of bodies.

What to do for heads, though? I've admired pipe-cleaner dolls—both vintage and new—that have painted wooden beads for heads. But I wanted something less....round? Something a little more handmade. Papier-mâché would be ideal, but it seemed a little labor-intensive. I mean, pipe cleaners are all about ease and fun, right? Then I had the idea to use "cheater" papier-mâché using my beloved brown paper tape (see pages 58-65 for details). And it worked out great!

TOOLS & MATERIALS

- Chenille stems—all the colors you love
- Corrugated cardboard
- Scissors or wire cutters
- White glue or hot glue
- Chipboard (recycled cereal box)
- Brown paper water-activated tape
- Scrap paper (newspaper, junk mail, and so on)
- Masking tape
- Acrylic paint, paintbrushes, and a water cup
- Acrylic paint pens (optional but recommended)
- Box cutter or craft knife
- Scraps of colorful paper
- Crepe paper streamers
- Little doodads and extra chenille stems
- Hats (see "Making Hats" on page 13)

Make the Pipe Cleaner Figure

I'm going to show you a couple of ways to make pipe cleaner bodies. Once you get a feel for it, you can make them using my method, or experiment with your own ways of twisting, looping, and bending. There's no wrong way to do it!

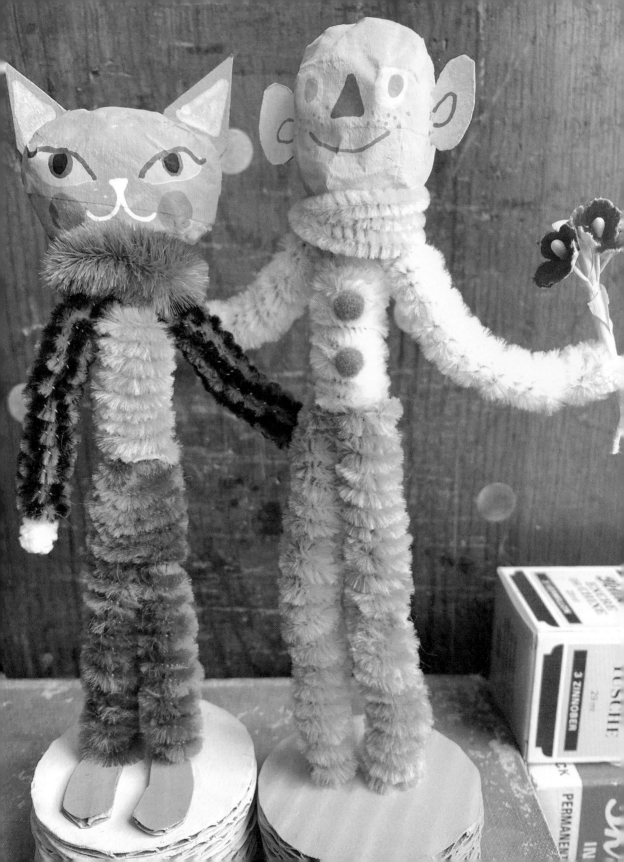

Basic Human Form

Step 1

Gather three pipe cleaners, and bend one of them in half. Twist the bend a few times; this will be the neck/base for the head. The untwisted sections are the legs.

Then place the second pipe cleaner between the legs, under the neck. These are the arms. Twist the arms around the legs to secure them. If you want them shorter, just trim them with scissors.

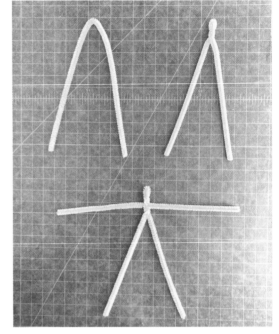

Step 2

To add clothes and/or fur and plump up your skeletons, make coils of chenille stems by rolling them around a pencil, a skewer, or anything round. Choose the size of your coiling tool based on how thick you want the arms, bodies, and legs.

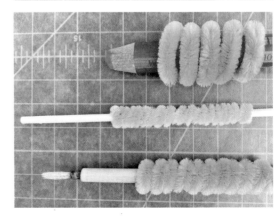

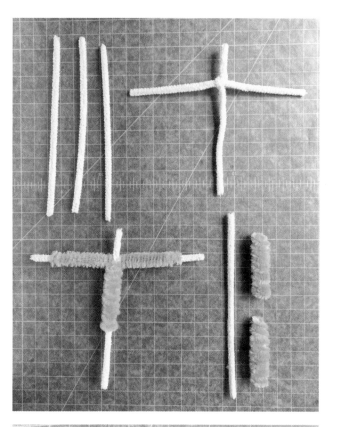

Basic Four-Legged Animal

Step 1

Gather three pipe cleaners. Twist one pipe cleaner around another one, as shown. Leave about 1 inch at the top of the perpendicular pipe cleaner. (This will be the neck.)

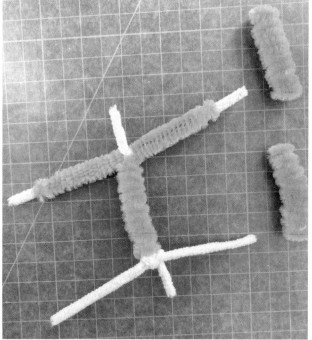

Step 2

Coil a pipe cleaner to make a body and slide it on as shown. You can add coiled pipe cleaners on the first two legs too.

Then twist another pipe cleaner at the base to make the back legs and trim off the excess chenille. Add coiled chenille to the back legs.

Step 3

If you want to add a tail, you can make one from a bit of pipe cleaner and slide it into the back of the coiled body. Glue it if you want.

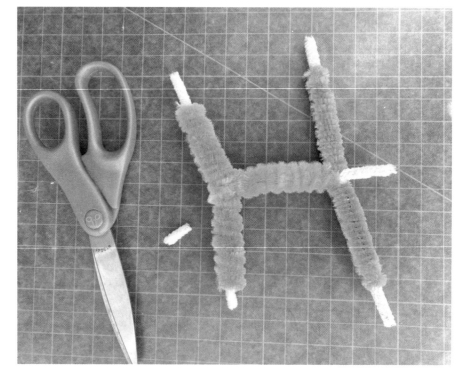

Step 4

Bend the legs to make it stand up!

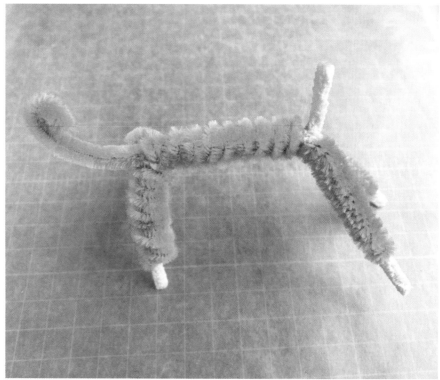

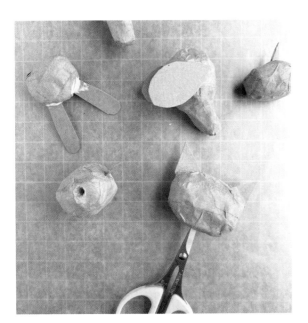

Put a Noggin on It!

The cheater papier-mâché technique used in the finger puppets project on pages 58–65 is perfect for making heads for these pipe cleaner buddies! Simply follow the steps in that project, except for adding the finger tube. You will end up with just the head.

Step 1

Once the head is dry, use sharp, pointy scissors to poke a hole in the base of the head. (This is where you'll put the pipe cleaner neck.)

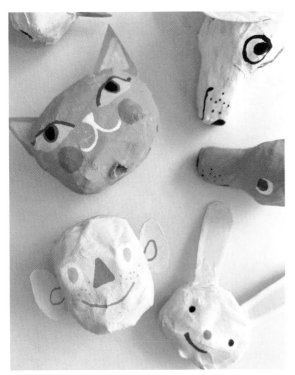

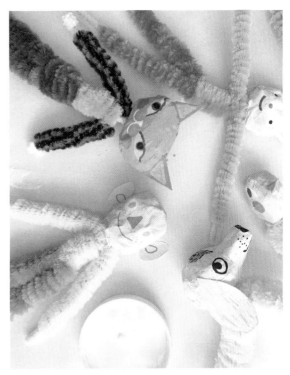

Step 2

Paint and embellish the head to match the figure, using paint and paint pens. Let it dry.

Step 3

Attach the head to the body by dipping the neck in white glue or using hot glue. Then put it in the hole you made in the base of the head. Let it dry.

Stand That Thing Up!

Putting your pipe cleaner figure on a base elevates it from a fuzzy craft to a statue! Here is a super-easy layered cardboard stand for your figure.

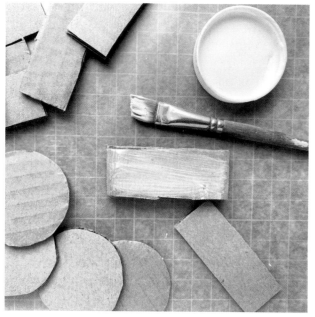

Step 1

Decide on a shape for your base, such as round, rectangular, or something else. I've traced the lid of my glue as my round base. Make sure you trace or measure your shape at least six times. Cut them all out.

Step 2

Use a paintbrush and white glue to stick six or more layers of cardboard together. Don't use a super-thick layer of glue or the cardboard layers will slide around. If you find them sliding, secure them with a rubber band or two while they dry. Let dry completely.

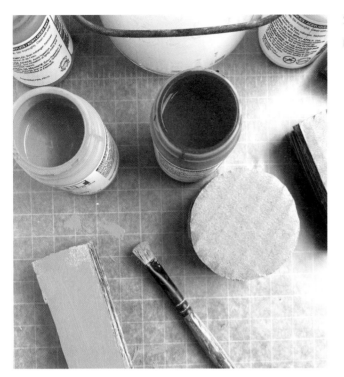

Step 3

Paint the base and let it dry.

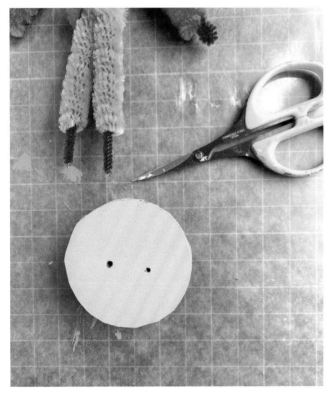

Step 4

Poke holes in the base with pointy scissors or an awl, and insert the pipe cleaner legs. You can add a blob of glue in each hole if you like.

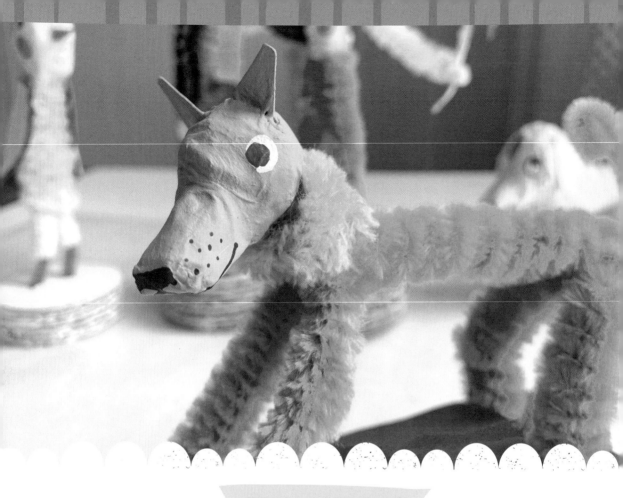

TRY THIS TOO!

I enjoy embellishing my figures with extra chenille scraps, painted bits of cardboard (wings, for example), hats (see page 13), and fake flowers or greenery (you can find this in most craft stores). Play with your supplies and see what you come up with!

Sometimes, I like to make shoes! It's really easy:

1. Grab some painted cardboard and scissors.

2. Draw shoe shapes on it and cut them out.

3. Cut little notches in the back of the shoes.

4. Put a little glue on the bottom of each shoe and slide the shoe onto the pipe cleaner leg where it meets the base. Let it dry and you're done!

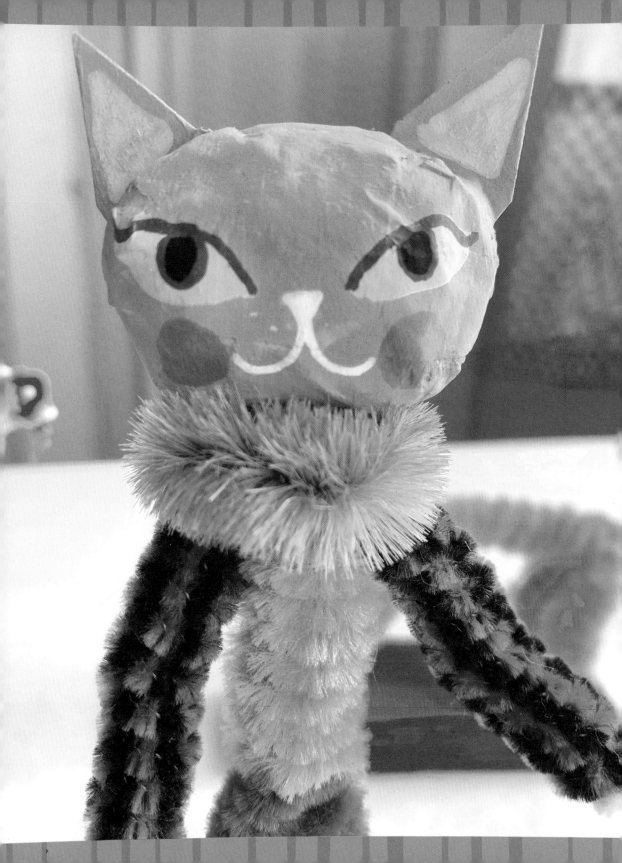

CRAYON RUBBINGS

When I was in my twenties, I worked in a dark and dingy and wonderful used bookstore. It was there, on a dusty shelf, that I came upon a book about crayon rubbings from 1967. I'd made crayon rubbings when I was a kid: coins, a comb, tree bark, and lots of other textures. But I'd never made rubbings from my own cut-out imagery, which is what the book was all about. Complex and layered compositions made by children crowded the pages of that book, and I loved the simplicity and depth of the technique. I was hooked!

TOOLS & MATERIALS

- Crayons
- Thin paper: printer or drawing paper, or experiment with tracing paper or rice paper if you have it
- Card stock or manila folders
- Scissors
- Glue stick
- Low tack tape, like painter's tape or washi tape
- Rubbing plate

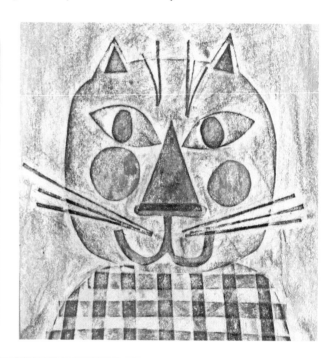

A NOTE ABOUT CRAYONS

Crayola® crayons are foolproof for this project. They have never let me down and I like the texture. Any other major wax crayon brand will work well too. I've also used fine-art crayons and those work OK, but they can be too rich and add too much pigment. I do NOT recommend using super-soft crayons made of soy wax, as they don't rub evenly and tend to make a clumpy wax buildup that obscures your rubbing. Along those lines, don't use oil pastels, either. If you want to use a harder coloring tool, there are several brands that make colored-pencil sticks (basically the insides of a colored pencil but thicker and with no wood). A plain old crayon works great every time, though!

Step 1

Decide what you want to make or experiment with the technique by making an abstract piece. I'm creating a cat portrait!

Use a piece of smooth card stock—this will be your rubbing plate base onto which to build up the imagery.

Begin cutting shapes from another piece or pieces of card stock. You can draw the components first if you want, or you can free cut. I like to free cut and play around with scale. It's no big deal if you don't like something; you can just cut a new piece.

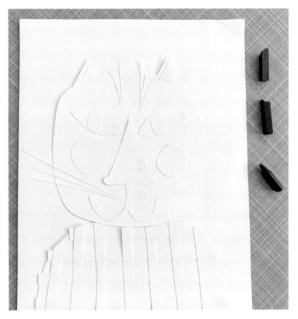

Step 2

The thing that makes rubbings interesting is the overlapping shapes and layers. So, build up your image by cutting base pieces. Glue them down with just a bit of glue stick (you don't need a lot of glue; it's just to make sure it doesn't move around).

Step 3

Add smaller triangles on top of the ears for the inside of the ear. Also make eyes and an iris, a nose, and a mouth. Whiskers! See how they go across the mouth line and off the face? That's OK; it just adds to the texture! I've added overlapping strips of card to make a gingham pattern on the cat's shirt.

Once you've made your rubbing plate, test it out!

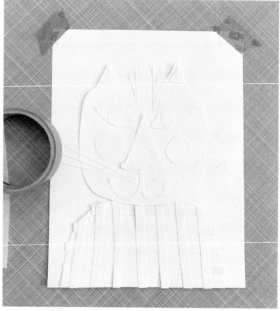

Step 4

Remove the wrappers from your crayons.

Step 5

Time to break your crayons! Smaller crayon pieces are easier to hold and give you more control over the rubbing. I give you permission to break your crayons on purpose!

Step 6

Tape the rubbing plate to your work surface. Make sure to tape just the edges, as your rubbing will pick up the tape lines if they are too close to the imagery.

If you can't stand peeling paper off crayons, simply soak them in cool water until the wrappers come off. Works like a charm!

Step 7

Place a piece of blank paper over the rubbing plate and line it up. Tape it to the top of your work surface.

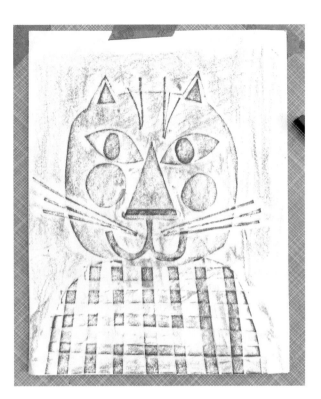

Step 8

Hold the crayon horizontally, using your other hand to hold the paper down, and begin rubbing the paper lightly. You'll see the image begin to appear. This is just a test, so use one color—preferably a darker one—to get a general idea of your image.

If you like it, great! If not, you can take some time to add or subtract things from your rubbing plate. Test it until you're happy.

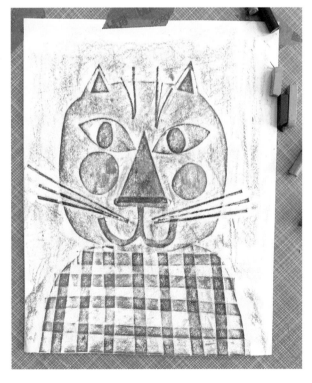

Step 9

Now you're ready to make your finished piece. This is your place to experiment! If you want your work to be all one color, that's totally fine. If you want to make your work more layered and colorful, do a single, darker color rubbing of the whole piece.

Here, I've added to my one-color rubbing by going over smaller areas with different colors. This is where it's super helpful to have shorter crayon bits, so you can zero in on the eyes or other small details without marking up the rest of the picture. Play around with how much pressure you use and see what happens!

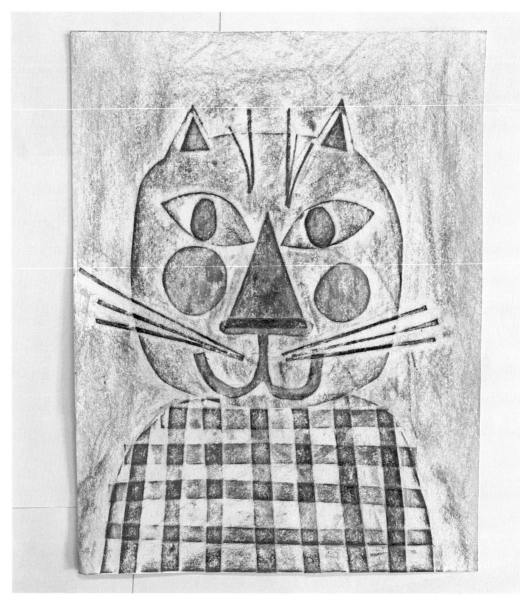

Note that this is a messy-ish art technique, and there will be marks on your paper in places you didn't mean to color no matter how careful you are. That is one of the charms of crayon rubbings. Embrace it!

Step 10

When you've added all the color details you want, you can call it done. You can also remove the rubbing plate from under the paper and use a crayon to color in the background around your image.

Tada! Isn't that fun? This is my cat, Roger.

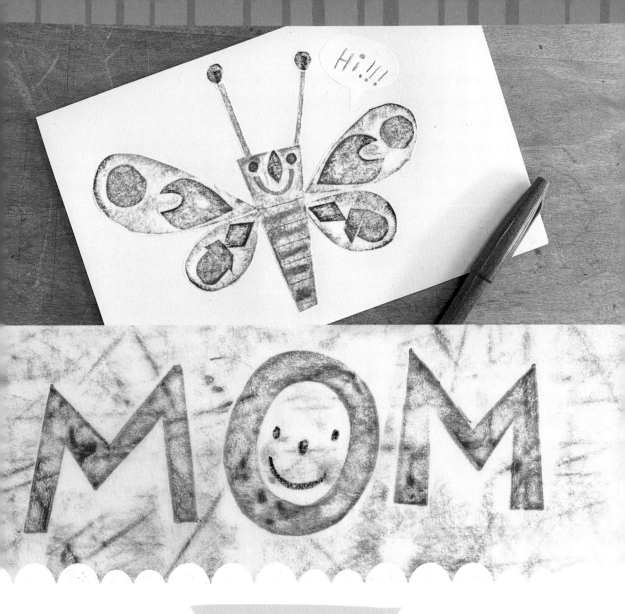

TRY THIS TOO!

At the top is an example of a smaller rubbing. I've made the butterfly rubbing on a piece of rice paper, and then I've cut it out and pasted it to the front of a card.

You can cut out letters too and spell out anything, or try using alphabet stickers on your rubbing plate.

The great thing is that you can use the plates over and over, so try making holiday cards or thank-you notes with this technique.

ORACLE CARDS

Oracle cards are a tool that can provide guidance, a different perspective, encouragement to follow your instincts, or a bit of meditative time with your thoughts. More specifically, they're a set of cards containing words, symbols, and images that can assist you when you need a bit of help problem solving or a little push in the right direction. They aren't magic—more like a way to focus your thoughts. A sweet gift of intuition, oracle cards are wonderful to make for a friend (or yourself) during a transition or challenging time.

TOOLS & MATERIALS

- Scissors
- 11" x 15" watercolor paper
- Paints, acrylic paint markers, colored pencils, painted paper tape, and so on. Use whatever you love to decorate this project.
- Pencil
- Card stock
- Optional: glue stick

You can make these cards truly your own: any size or shape you like, and the imagery can be collaged, painted, drawn, or mixed media! The imagery can be literal or symbolic; you can add words or not...anything goes! My cards are small with very simple symbols and words and a bit of collage using painted paper tape (I cannot resist it!).

Step 1

First, plan your approach. Consider the size and shape of your cards (I'm using a small card that measures 2" x 2.5" as my guide for size and shape), and how many cards you'd like to include (I've chosen 10). Also think about what you'll use to decorate your cards. Gather all your supplies for that!

You're going to paint or somehow decorate the card backs to help make a cohesive deck. Do this for all the cards at once by painting the entire back of the watercolor paper. Here, I've painted it black and added a messy diamond grid with a white paint marker—it's an easy pattern. Let it dry completely.

Step 2

Turn over your paper and trace the cards using a template. You could also cut your paper down with a paper cutter. I'm making 10 cards for my deck; make as many as you feel inspired to do!

Step 3

Carefully cut out all the cards.

Cut a few extra just in case!

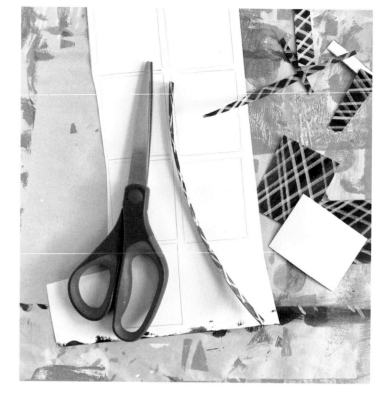

Step 4

Now begin decorating them! You can draw your design with a pencil before painting if you like, or you can work intuitively. I've done a little bit of both.

Using a limited color palette throughout the whole deck can make it feel harmonious.

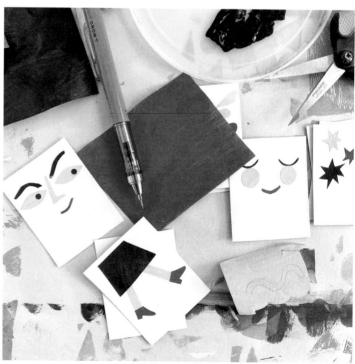

Step 5

Add images and words until you're happy. You can pick a specific theme, like trees or animals. Use collage from magazines or vintage books, or rubber-stamped words. These cards can be as simple or as ornate as you'd like.

Press the cards under a stack of heavy books overnight to flatten them. This is optional but recommended!

Step 6

To present the cards, make a simple half box. Trace your card template in the middle of a piece of card stock.

Step 7

Measure the thickness of the stacked deck and use this measurement to add sides around the traced box. (My measurement was ½ inch.)

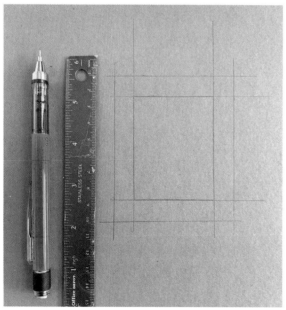

Step 8

Cut out the box.

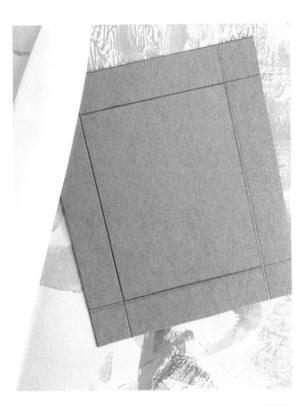

Step 9

Score the lines you just drew.

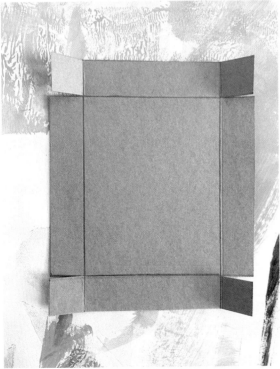

Step 10

To make tabs, cut along the lines as shown.

Step 11

Fold up the edges of the box.

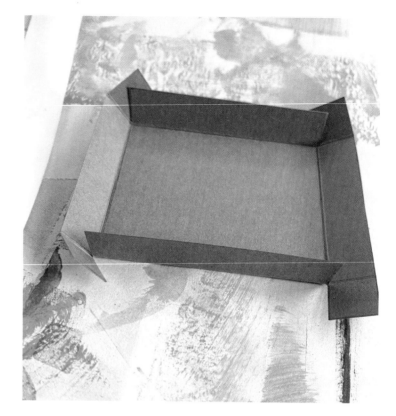

Step 12

I've used paper tape to secure the tabs, but you can also use glue. And here's a simple box to hold the cards. Add a bellyband, and you are ready to give a most thoughtful gift!

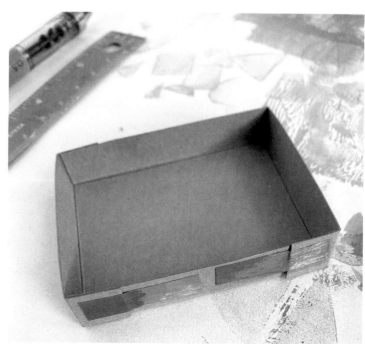

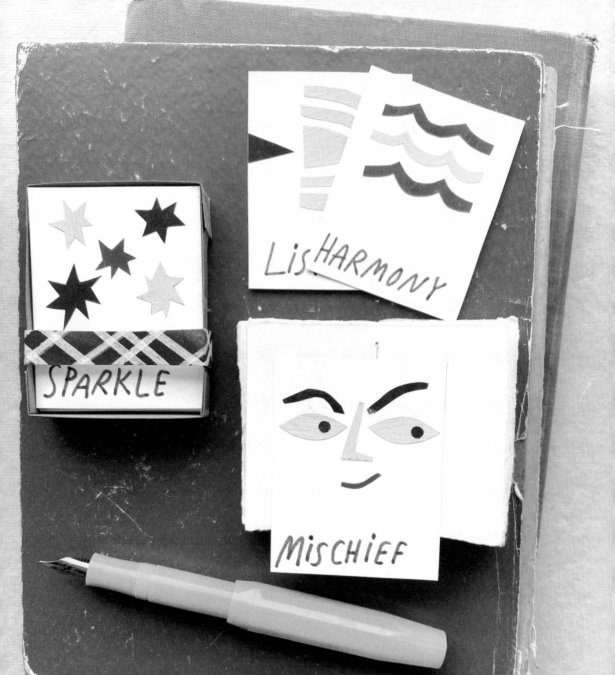

VOLVELLE

What on earth is a volvelle? I'm sure you've seen one before, but maybe you're like me and just didn't know the official name! Long ago, volvelles were used to do math and chart the movement of stars. They were complex paper calculators featuring circles. Don't worry, though: We'll be making simple volvelles that have little messages, bits of advice, or fortunes...whatever you decide!

This project requires a bit more precision than most of the others in this book. I've given you measurements for one version of a volvelle. I suggest making one, following the directions and measurements first—just to see how it all works. After you understand it, you can experiment with different dimensions to make it your own!

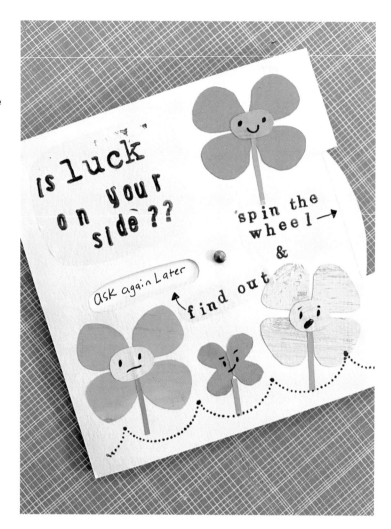

TOOLS & MATERIALS

- Compass
- Scissors
- Craft knife
- Card stock in various colors of your choosing
- Colored pens and markers, paint markers, colored pencils, rubber stamps, painted paper tape—whatever you enjoy!
- Ruler
- Brad
- Glue stick
- Pencil and eraser
- Awl or needle

Step 1

Cut a strip of card stock measuring 5 inches wide and 10½ inches long. Score it to make a crease at 5 and 10 inches, which should give you a piece of paper divided into two 5-inch sections and a section measuring ½ inch.

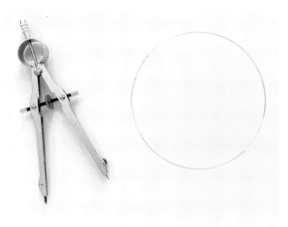

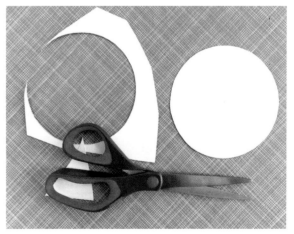

Step 2

Use a compass to make a circle on another piece of card stock. It will need to fit into the 5-inch square area of your folded card. Use a ruler to measure the radius on the compass. Set the compass at 2¼ inches and make the circle.

Step 3

Very carefully cut out the circle.

Step 4

Lay flat the long strip you scored, with the smallest section at the left as shown. This is the inside of the volvelle, which you will not see when it is complete. I like to make notes and marks on the inside, so I don't get confused while I'm creating.

Step 5

Put the circle you cut inside the square area as shown (the square labeled "front"), placing the edge of the circle right up against the edge of the fold.

Step 6

Make a pencil mark through the circle's center hole that was created by the compass. Use an awl or a needle to make a small hole where you marked.

Step 7

Turn the card over and place a small brad through the hole. Turn the card back over, place the circle piece on the brad, and fold down the prongs. Then use a pencil to trace the circle on the inside of the card.

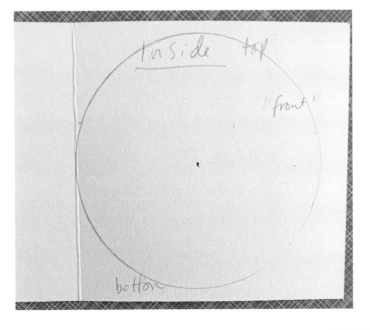

Step 8

Undo the brad and separate the circle from the card for now.

Step 9

Now make the cutout for spinning the circle. Fold the card as indicated, so the inside is showing, and measure 1½ inches down from the top of the card and 1½ inches up from the bottom.

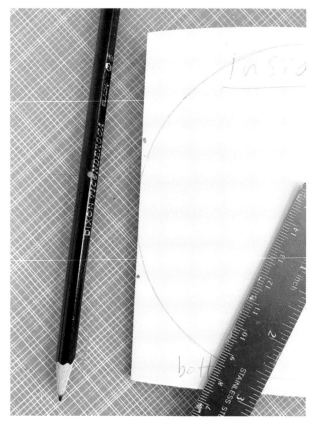

Step 10

At each measurement point, measure a scant ¼ inch inside the fold, and then connect the lines.

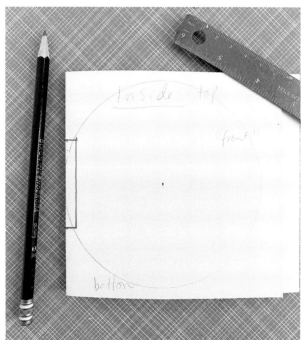

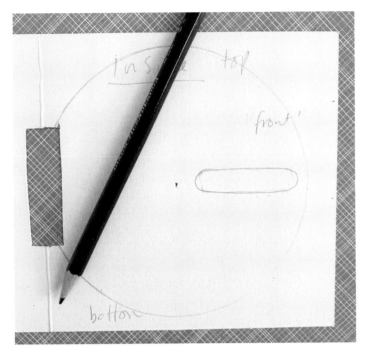

Step 11

With a craft knife, cut out the small rectangle you've just drawn. Then open the card back up so the inside is facing up.

Now we'll cut out the window. On the opposite side from the spinner cutout, draw a long, thin rectangle. Make sure to leave ¼ inch on either side of the window to accommodate the edge of the circle and the center brad.

Step 12

Cut out the window!

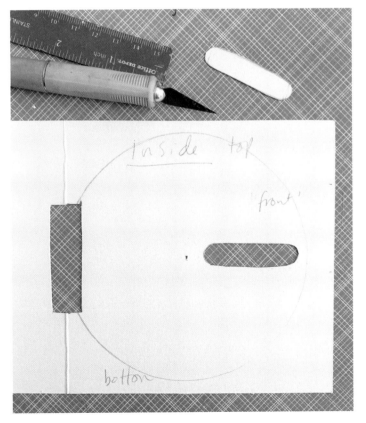

Step 13

Add the circle back to the card with the brad like you did before. Turn the card to the front. With a very light pencil line, outline the window onto the circle. Spin it slowly until the outline is just out of sight, and outline the window again. Keep doing this until you return to the first outline. I've traced 11 windows, which means I'll have 11 spaces to add fortunes.

Remove the circle from the card to write the fortunes.

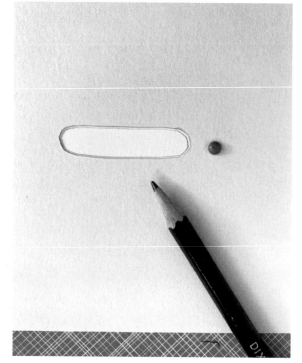

Step 14

Add the messages. I'm creating a fun fortune-teller that answers yes or no questions. Anything goes with the words: a collection of love messages, little pictures...you name it!

Then erase the window outlines you made.

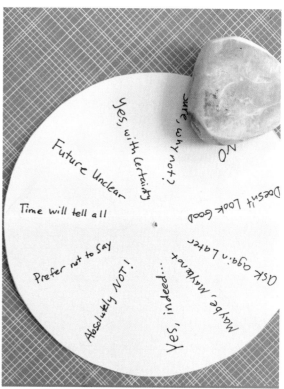

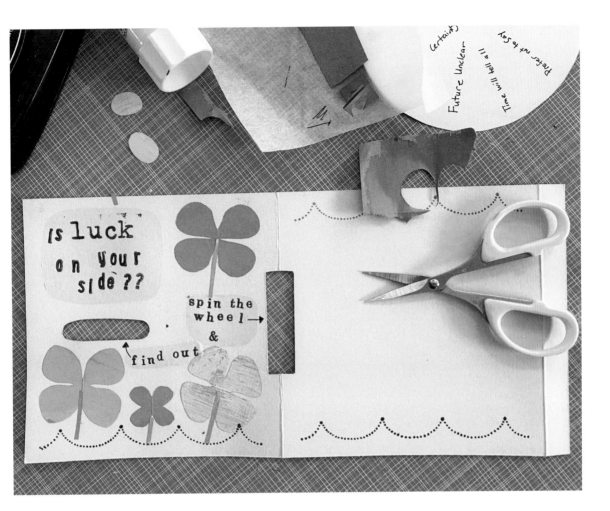

Step 15

Now it's time to decorate the front. You can add lettering and imagery. I've collaged with my painted brown paper tape and rubber stamps. Any way you want to design the front will be awesome. Then put everything back together with the brad.

Step 16

Once you're happy with everything, apply a glue stick to the ½-inch section of the card and carefully fold the card, sticking the glued flap to the inside front cover and pressing to stick.

Step 17

Take it for a spin!

Whew! That was a complicated one! I hope you enjoyed it and are inspired to make your own. It's pretty fun!

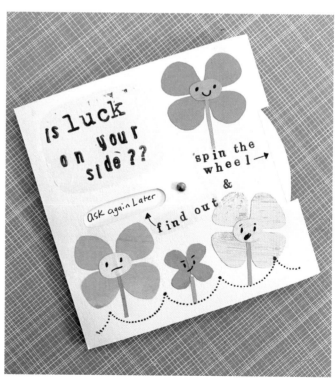

Dear Megan,

to find out your future, ask a yes or NO question + spin the wheel with your eyes closed. Open your peepers to see the answer!

xo,
S

TRY THIS TOO!

If you're giving this as a gift, you can write a personal note on the back.

HAPPY LITTLE BOOKLET

This little book was inspired by an ad I got in the mail. I have no memory of what was being advertised, but I was charmed by its built-in cover and the way it folded out using just a single piece of paper! I've used this technique to send letters, as well as for pocket sketchbooks. It's also a fun way to share a recipe, and it's the perfect size for a scrapbook of an event or day trip. You can make this with any size paper. I love making them on the smaller side, but maybe want to make giant ones!

TOOLS & MATERIALS

- Paper (Thin paper works well; anything from drawing or printer paper to lightweight scrapbook paper. I love to use old book pages for this project.)
- Scissors
- A bone folder, if you have one. Otherwise, a pen works just as well for creasing folds.

Optional ideas for decorating:
- Collage papers or painted paper tape
- Paint and paint markers
- Colored pencils, crayons, or markers,
- Rubber stamps
- A glue stick

Fold the Book

Step 1

Fold the paper in half lengthwise and open it up.

my fave

poisons

BLUebe

BIRD

Step 2

Fold the paper in half widthwise and open it up.

> To create a sharp crease, I like to use a bone folder or a pen to really press down the crease.

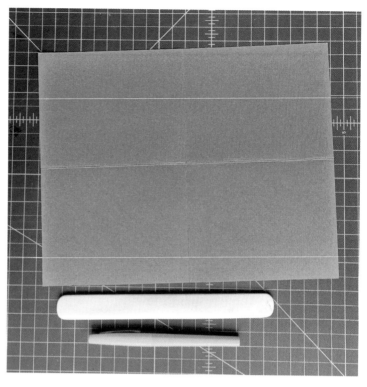

Step 3

Fold the outer edges to the inside, as shown.

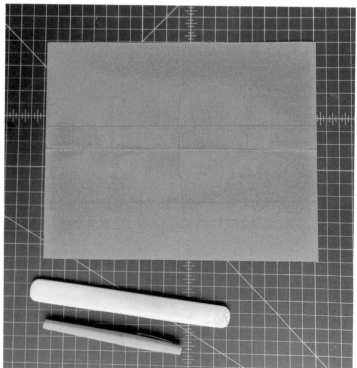

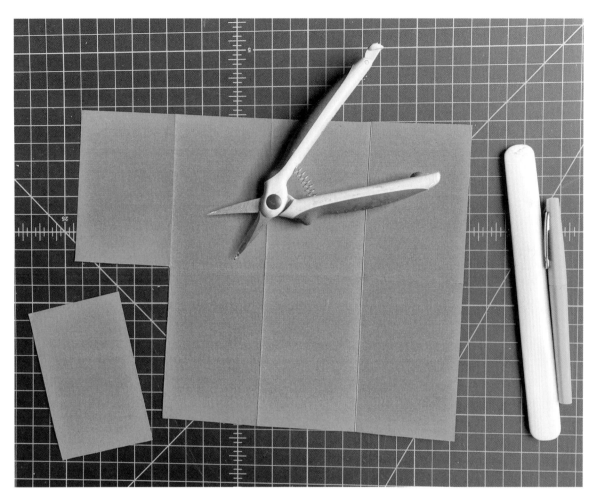

Step 4

The paper should now be divided into eight equal segments. Cut out the lower-left segment, as shown.

Note that for the folding instructions, I've used plain paper so you can easily see the creased lines. For my final project, I've used a page from an old book.

Make the Book

Step 1

Fold up the lower segment.

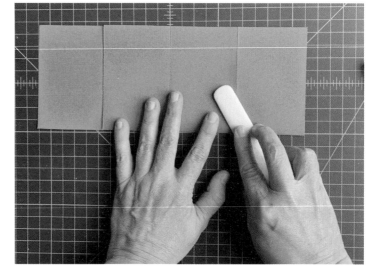

Step 2

Accordion the three segments.

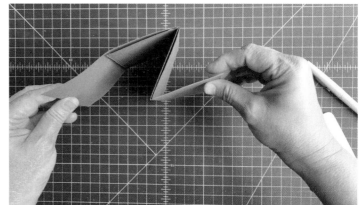

Step 3

Fold the final flap over the top; this is the built-in cover. Crease well so it lies flat. Now let's make it cute!

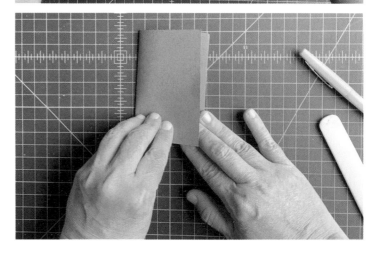

Decorate the Book

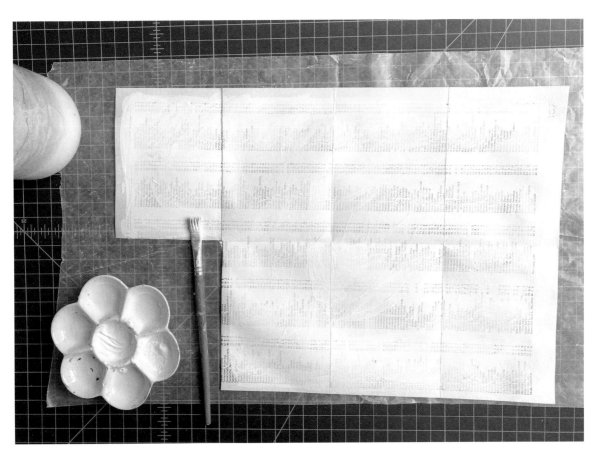

Step 1

When using old book pages, I like to paint the page with watered-down paint. I like the text to show through a little, but I find that covering it up a bit prevents it from competing with the text I will be adding to the booklet.

Step 2

This book is for a friend. I'm sharing my favorite blueberry muffin recipe.

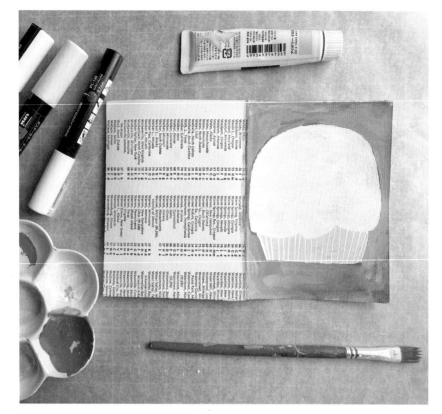

Step 3

I'm using a combination of collage and drawing to illustrate the recipe.

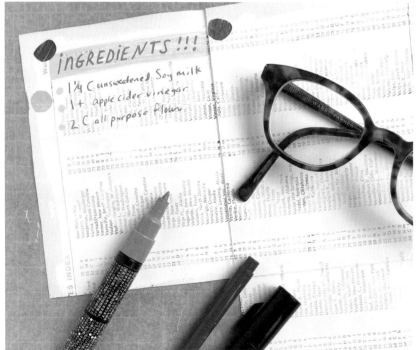

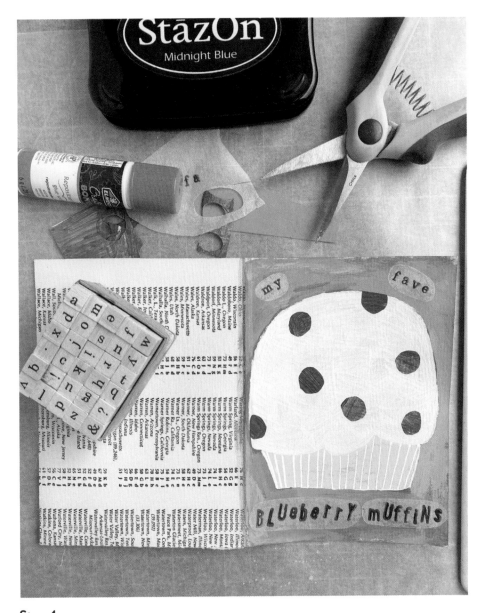

Step 4

To decorate the cover, I give it a title, and then I add more collage and drawing.

Once everything is dry, you can fold the book back up and press it under something heavy overnight. It should relax without springing open.

TRY THIS TOO!

You can also make a bellyband for your book, using the instructions from the Two-Color Foam-Printed Postcards project (pages 124–133).

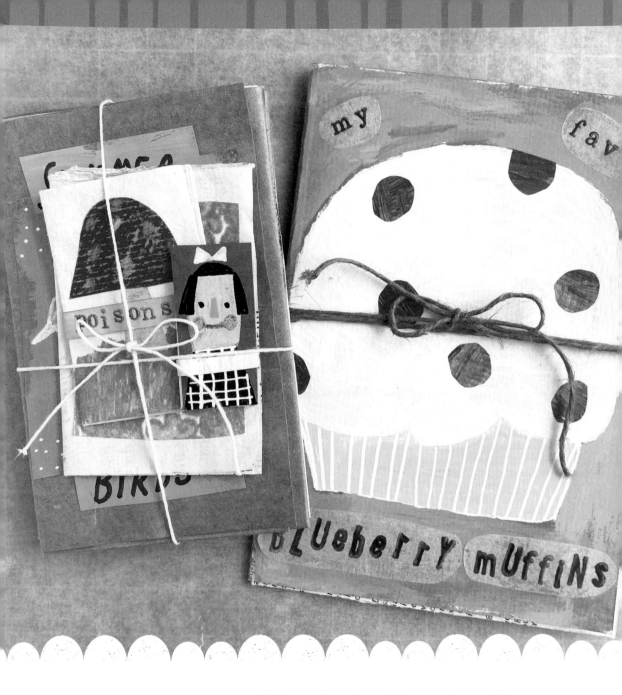

How you decorate your booklet will depend on the subject matter and however you like to create. My only guidance is to have fun! These are so easy to make; you may find yourself creating a stack of blank booklets to have on hand for whenever inspiration strikes! Keep it simple and enjoy yourself.

And there you are! A cute little something for a friend.

TWO-COLOR FOAM-PRINTED POSTCARDS

Stamping with craft foam is nothing new; you may have done it before! Craft foam has a nice give to it, and it takes paint and ink like a dream, so it works well as a printing material. And if you're crafty, you probably have a sheet or two in your house somewhere. This project takes foam printing up a notch and gives it a little more complexity.

TOOLS & MATERIALS

- Craft foam sheets (two to four, or more). You may need to experiment, so have a little extra on hand. Try to find the thicker ones; 6mm is ideal. Craft stores usually carry this thickness in only black or white.
- But if you only find the thinner sheets, get a few extra so you can layer them (more on this later).
- Sharp scissors
- Craft knife
- Glue (NOT hot glue)
- Card stock or premade postcards
- Acrylic paint
- Brayer
- Wide, flat paintbrush
- Marker or pencil

Over the winter, I just wasn't in the mood to make holiday cards, but as the end of December approached,

I decided I did want to send out some cards to celebrate the new year. Wanting to use what I had around the house, I rummaged. I found a pack of blank brown kraft postcards, a sheet of thick craft foam, and my trusty acrylic paint. I wanted to do some printing...and I wanted more than one color.

Two-color craft-foam printing was the answer! The results were so fun, and it was easy to crank out a bunch of postcards. I'm going to show you how to make postcards, but you can use this technique on paper, with paper tape, in an art journal, or wherever you feel inspired!

MAKING YOUR PRINTING PLATES

We'll use printing plates to transfer the design onto the postcards. In this case, we will make two plates, as we're doing two-color printing. The first plate will feature an allover pattern, and the second plate will have a message or larger graphic on it.

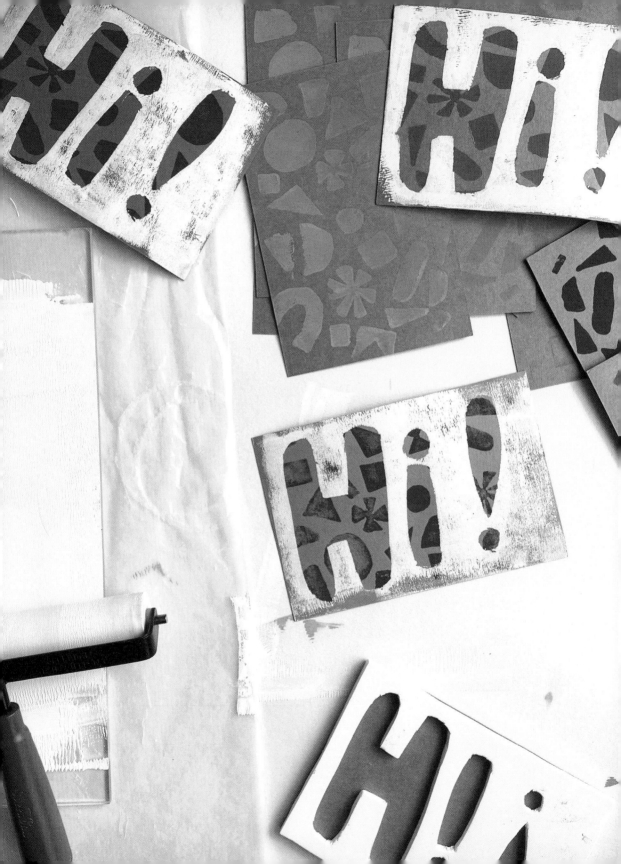

Decide what size to make your postcards if you're cutting them from card stock, or use premade postcards. I've used both in this example. Set aside two for your printing plates.

First Printing Plate: Allover Design

Step 1

Cut shapes (any that you like) from craft foam, and glue them securely in your preferred design onto one of the postcards (plates). A dense design looks best, so really nestle those shapes close together on the plate. Let it dry completely.

Step 2

Remember that whatever you put on your printing plate will be reversed when you print it. If you're doing an abstract design, this won't matter as much, but if you are using letters or numbers, you will need to glue them to your plate in reverse.

Second Printing Plate: A Larger Graphic or Message

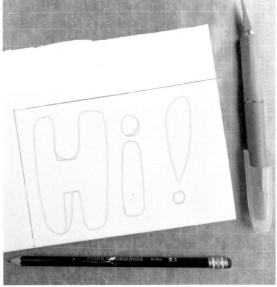

Step 1

Trace your postcard/plate onto a piece of craft foam.

Step 2

Lightly draw your design on the foam. I've done a word, but you'll notice that I haven't reversed it. I will explain!

Step 3

Use a sharp craft knife to cut away the word or design. Be careful to maintain the edges of the foam plate. Once everything is cut out, you will flip it over so that the word is reversed, and then glue it down to the plate. Easy, right?! Let it dry completely.

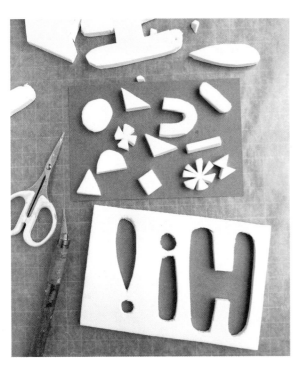

If you can only find thin foam sheets, glue three to four of them together to make a thicker sheet. Let it dry really well, and follow the directions for the project.

Print!

Set yourself up with plenty of space to spread out your cards as they dry. You'll print all of your cards with the first plate first, let them dry, and then print them all with the second plate.

Step 1

Place your first (patterned) plate on the table faceup. On a piece of plexiglass or a paper plate, roll out paint with a brayer or using a wide, flat paintbrush.

Step 2

Roll the paint onto the printing plate to create nice, even coverage.

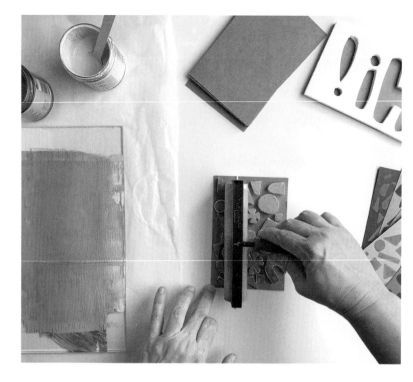

Step 3

Place a postcard facedown on the plate, taking care to line it up with the plate's edges. Rub the back of the postcard gently but firmly.

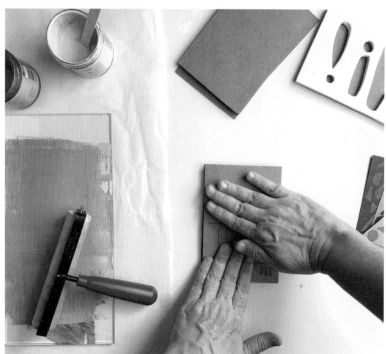

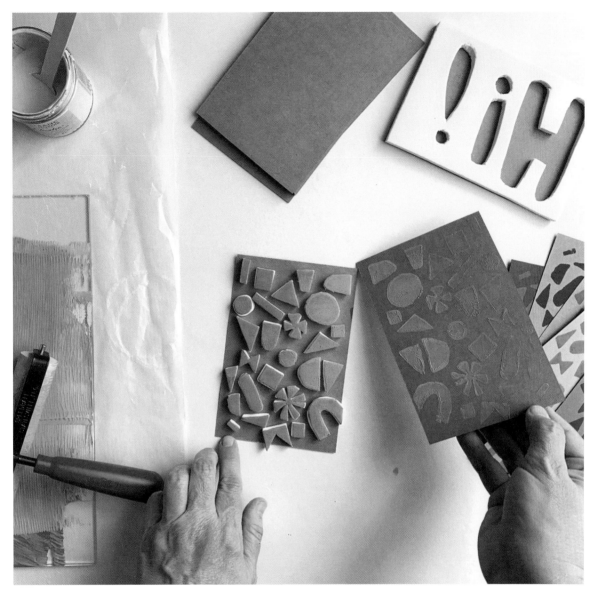

Step 4

Carefully peel the postcard up and check the print quality. You might find that you need to use more or less paint—just play around with it until you find a print you like.

Step 5

Print all of your cards with the first plate, rolling it with paint as needed, and let them dry completely.

Print the Second Color

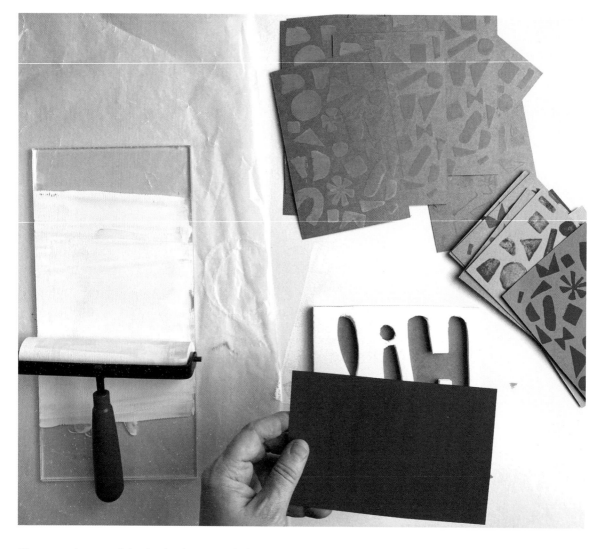

Change out your paint color for the second plate. Again, roll out the paint and create a nice, even coverage on the plate. Take a postcard with your printed pattern and place it facedown on the plate, and rub it down. Pay special attention to the outer edges. Peel up carefully and check for print quality. Once you are happy with your paint coverage, keep on rolling out paint and printing postcards until you're done. Let them dry completely. Aren't they cool?!

You can keep these cards for yourself or send them to friends and family. You can also make little sets of cards for gift giving. To make it an extra-special gift, wrap the cards with a hand-printed bellyband—a strip of thick paper that wraps around the cards like a belt and secures them in a little packet.

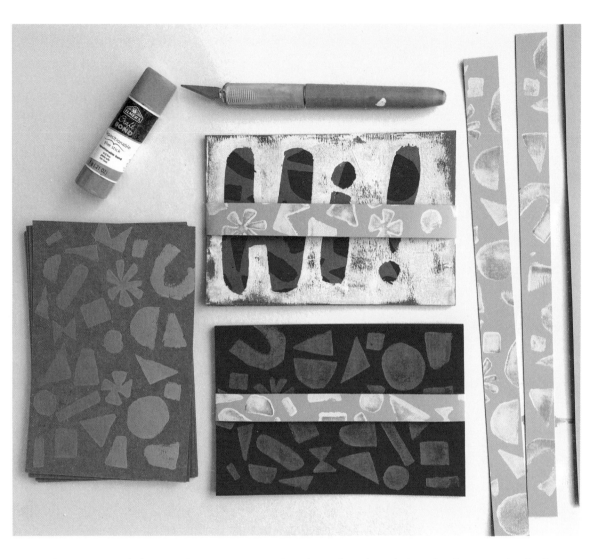

I've used my patterned plate to print onto a contrasting piece of card stock. Once it's dry, I cut strips for the bellybands. Use a little dab of glue stick to secure the overlap of the band on the back of the packet and you have a sweet little gift!

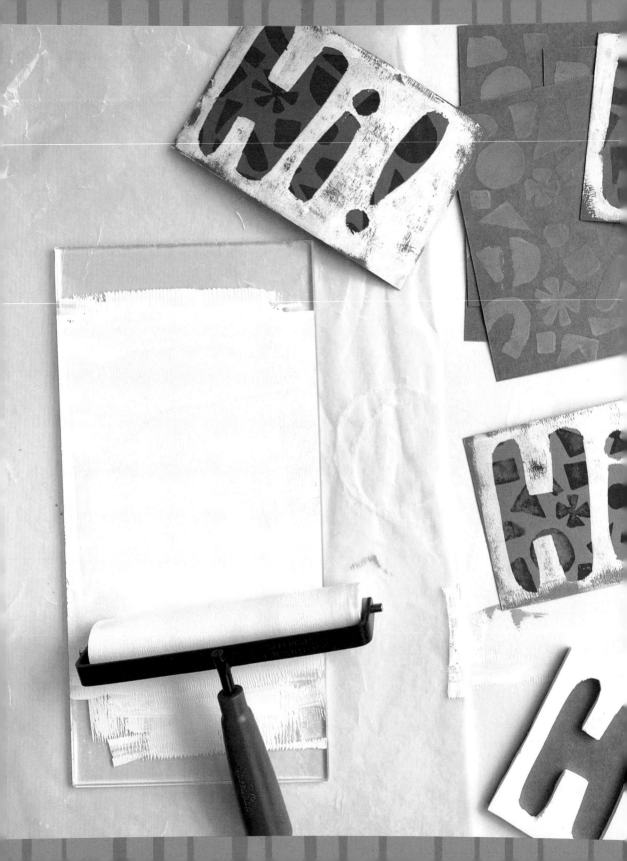

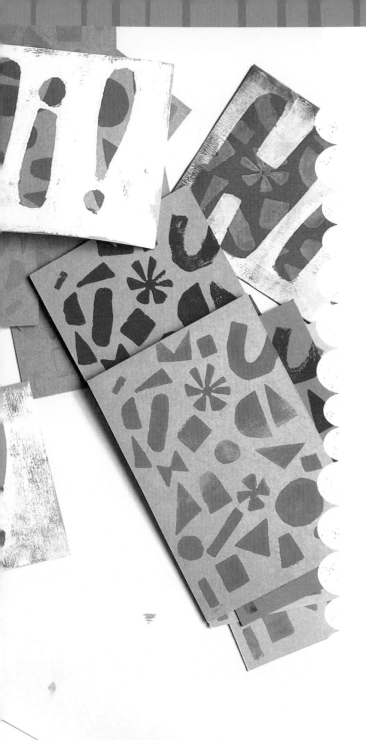

TRY THIS TOO!

A fun variation is to make plates to print on brown paper tape! To make plates, measure out some cardboard the same width as the tape. Print it just like you did for the cards. Now you have fun tape to use on packages or for collage!

CLEANUP

You can use these plates again and again. To clean them, gently wipe them off with a damp paper towel, or simply let the paint dry on the plate.

BOXY PALS

Am I the only one who keeps little cardboard boxes just because I like the shape or size? Sometimes I think, "I know I could use that for...something," and I totally do use them to make boxy pals! Boxy pals are just plain silly and joyful to make. They're dimensional sculptures that use recycled materials, scraps, and imagination. One thing that's especially freeing about this project is that you kind of just roll with the shapes of the boxes and they tell you what they want to be. Dangling limbs make these buddies even more appealing. This is a super project for a rainy day—you don't need a lot of supplies, and the results are always fun. Let's begin!

TOOLS & MATERIALS

- A variety of small, recycled cardboard boxes. Make sure you like the shapes and sizes!
- White paint or gesso
- Acrylic paint and paint markers
- Awl or needles
- Hot glue gun
- Pipe cleaners
- Scissors
- Craft knife
- Corrugated cardboard

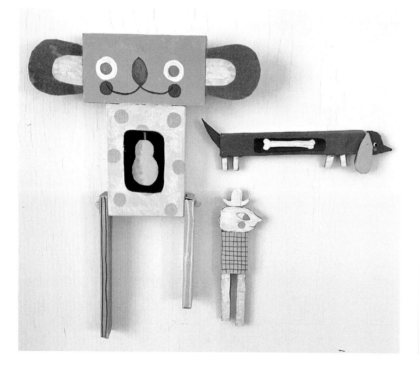

I'm walking you through one way to assemble your pals, but you can do these steps in any order you want. This project is improvisational. It's best not to plan too much and see where the cardboard takes you!

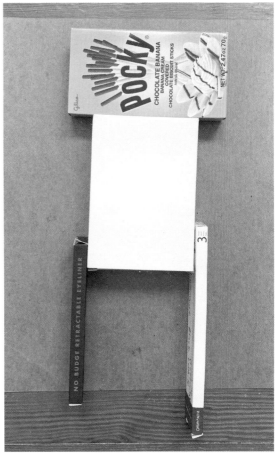

Step 1

Gather your boxes. Have more than you think you will need!

Step 2

Start planning your pal by holding shapes together. What looks like a good head, a good body, and good legs? Is it a person, an animal, a robot, or a made-up creature? What inspires you with these boxes?

I'm seeing a simple body, head, and uneven legs with my pieces. I think it's going to be an imaginary creature. I'll make ears to go with it a little later using corrugated cardboard scraps leftover from the articulated dolls project (see pages 66-73).

Step 3

Prime the boxes with white paint or gesso before assembling. This is an optional step, but it's worth the extra time.

Step 4

Hot glue the head to the body... or any parts you want to glue together. All of our boxy pals will look different! I'm going to attach my legs so that they dangle, so I'm setting them aside for the moment.

Step 5

If you don't have the right sizes of boxes for limbs, ears, or really anything, you can use corrugated cardboard cut to the size and shape you need. I recommend gluing two pieces of cardboard together to make a thicker surface to glue to the boxes.

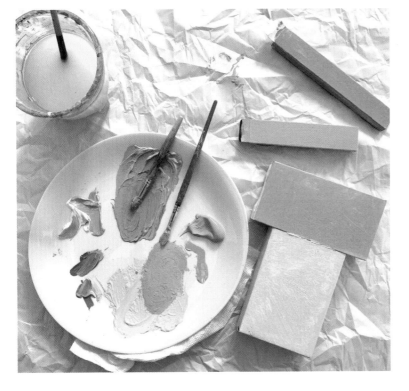

Step 6

Before attaching any dangly parts or cardboard features, we'll paint!

If you like, draw your design on the primed boxes first. Then add paint, letting it dry between layers. Use paint markers for small details.

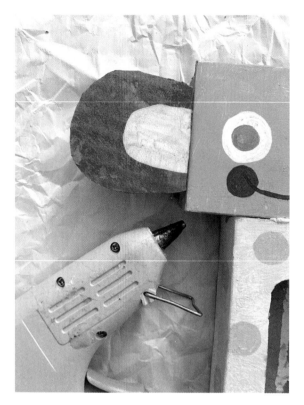 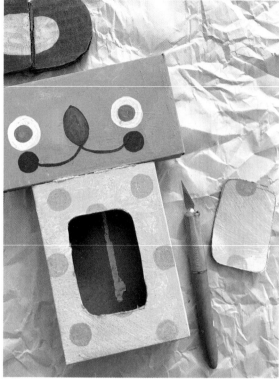

Step 7

Glue cardboard extras to the body or limbs. I've used cardboard for my ears. My sculpture doesn't need arms, but you could use cardboard for that too.

Step 8

This step is optional, but I like to do it before I add anything dangly, so I don't accidentally cut or crumple something. Use a sharp craft knife to carefully cut a shape from the body.

If you'd like, you can take even this step further and make a small shadow box in the body of your figure like I've done.

Step 9

Paint the inside of the shadow box. No need to paint the entire inside of the box—just the area that shows through the cutout. Let it dry completely!

Then make a simple image. It can be as simple as a heart, more symbolic, or even just funny. The image should fit easily within your shadow box.

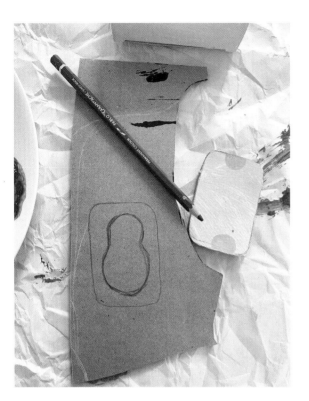

Step 10

Cut out the image carefully and paint it.

Step 11

Glue together some scraps of cardboard to make a base for your shadow box image. Then glue the image to the base.

Step 12

Glue the whole thing into the shadow box.

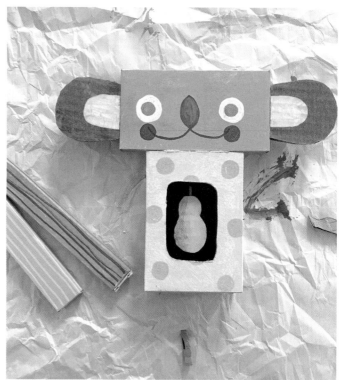

Attach the Dangly Bits

Step 1

Poke holes in the box body and legs with an awl or needle.

Step 2

Make a little scrunched-up knot at one end of a pipe cleaner.

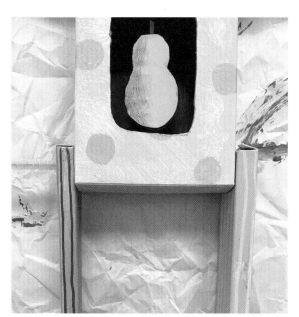

Step 3

Thread the pipe cleaner through the box and the legs of your pal.

Step 4

Secure the wire with a little twist and trim if needed.

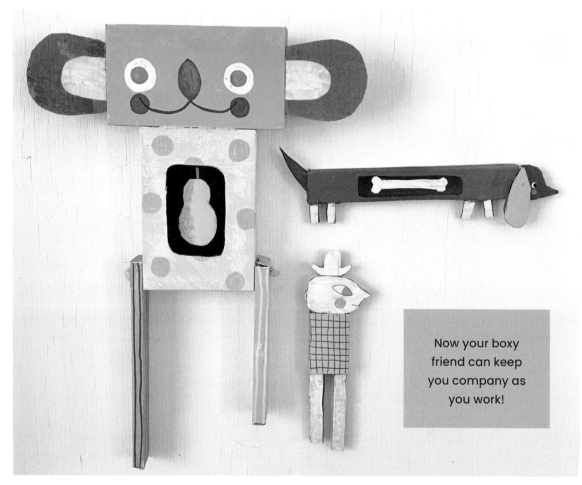

Now your boxy friend can keep you company as you work!

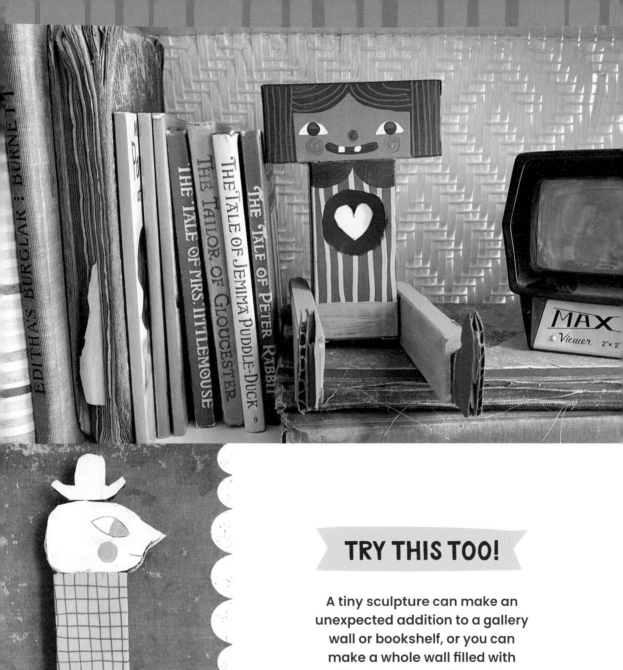

TRY THIS TOO!

A tiny sculpture can make an unexpected addition to a gallery wall or bookshelf, or you can make a whole wall filled with nothing but boxy pals! Go big or tiny or anywhere in between. Play around and see what happens!

143

ABOUT THE AUTHOR

Sarah Hand is a papier-mâché artist, an illustrator, and an art teacher. A puppet show she created when she was 30 inspired her to pursue the art of papier-mâché in earnest. This messy, fun medium was an undiscovered well of inspiration for Sarah. Creating creatures, dolls, and puppets led her to teach the magic of papier-mâché to children and adults alike.

Sarah has taught for more than 15 years at the Virginia Museum of Fine Arts, the Visual Arts Center of Richmond, Studio Two Three, art retreats, and online. Her work has been featured in *Somerset Studio* magazine, and she has had many solo art exhibits.

When she's not elbows deep in paste and paper, you can find Sarah painting, drawing, and dreaming up stories and images for picture books.

Sarah lives and creates in Richmond, Virginia, with her husband, Phil, and their three-legged cat, Roger.

For Catherine and Robin, crafting friends for life.